LIFE
AND STILL LIFE
TONI CATANY

1. *Changó*. La Habana, Cuba 1995

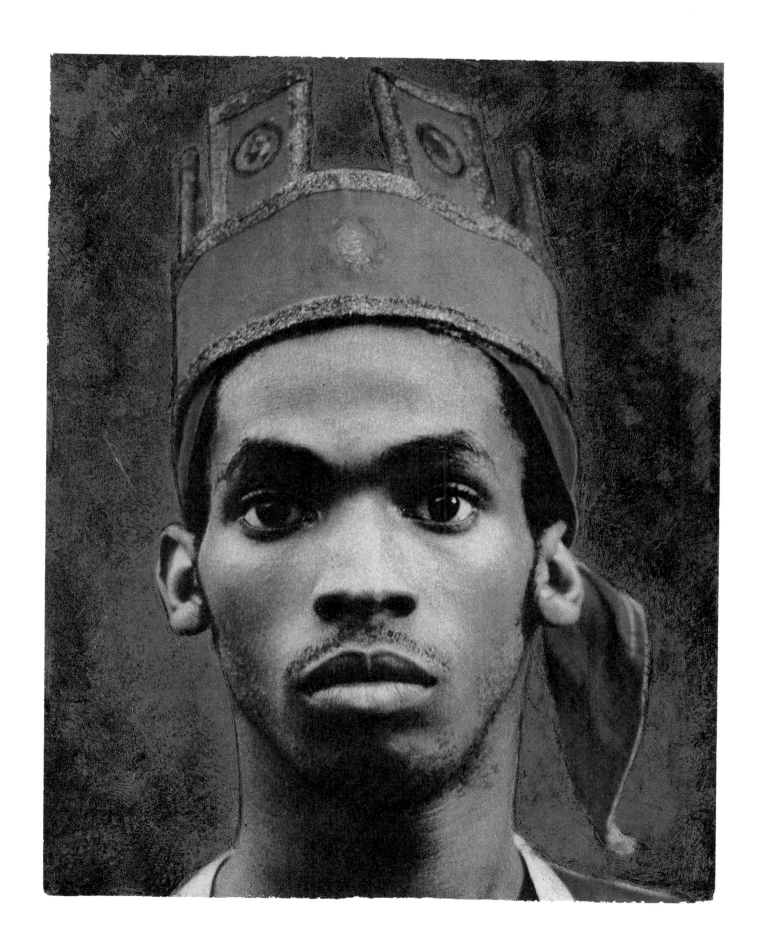

EUROPEAN PUBLISHERS AWARD
FOR PHOTOGRAPHY 1997

JURY

Reinhold Mißelbeck
Curator of photography, Museum Ludwig, Cologne

Günter Braus
Edition Braus

John Zvereff
Manager of the Contemporary Art Museum of Barcelona

Andrés Gamboa
Lunwerg Editores

Dewi Lewis
Dewi Lewis Publishing

Mario Peliti
Peliti Associati

With the collaboration of

 LEICA

Copyright © 1997

For this edition
Edition Braus (Germany)
Lunwerg Editores (Spain)
Dewi Lewis Publishing (United Kingdom)
Peliti Associati (Italy)
Éditions Hazan (France)

For the photographs
Toni Catany

All rights reserved
ISBN: 1-899235-41-8
D. L.: B-40102-1997
Graphic design and layout: Lunwerg Editores
Leader of the 1997 project: Lunwerg Editores
Printed in Spain

EUROPEAN PUBLISHERS AWARD FOR PHOTOGRAPHY 1997

LIFE
AND STILL LIFE
TONI CATANY

DEWI LEWIS

PUBLISHING

2. *Bodegó Nº 1*. Barcelona, España 1995

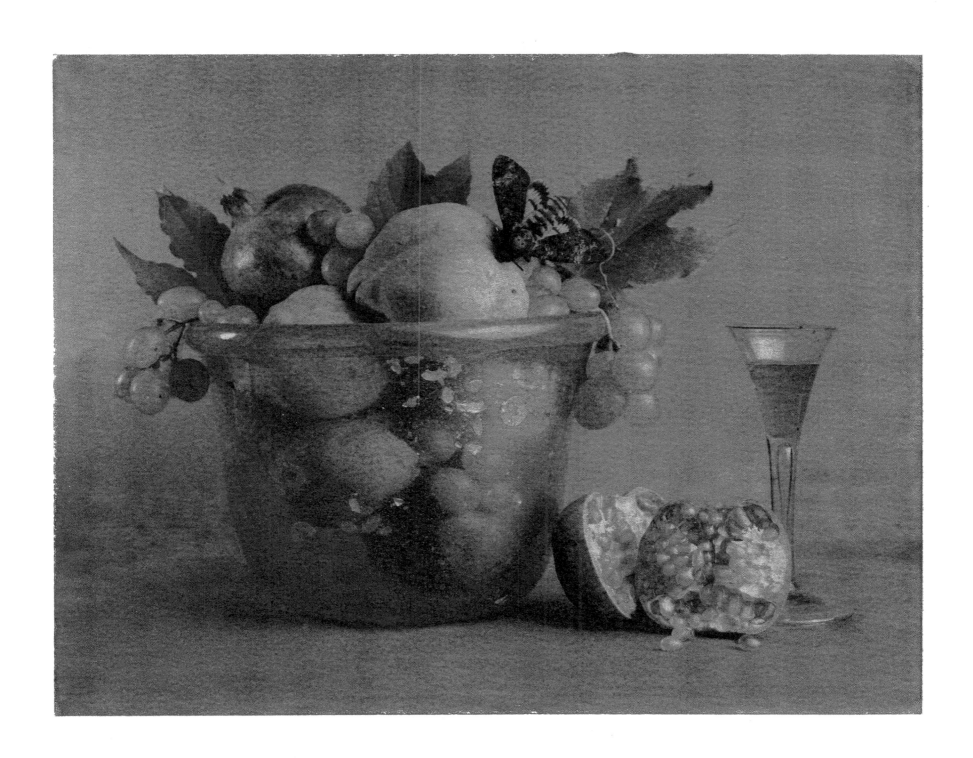

3. *Roses Blanques*. Barcelona, España 1995

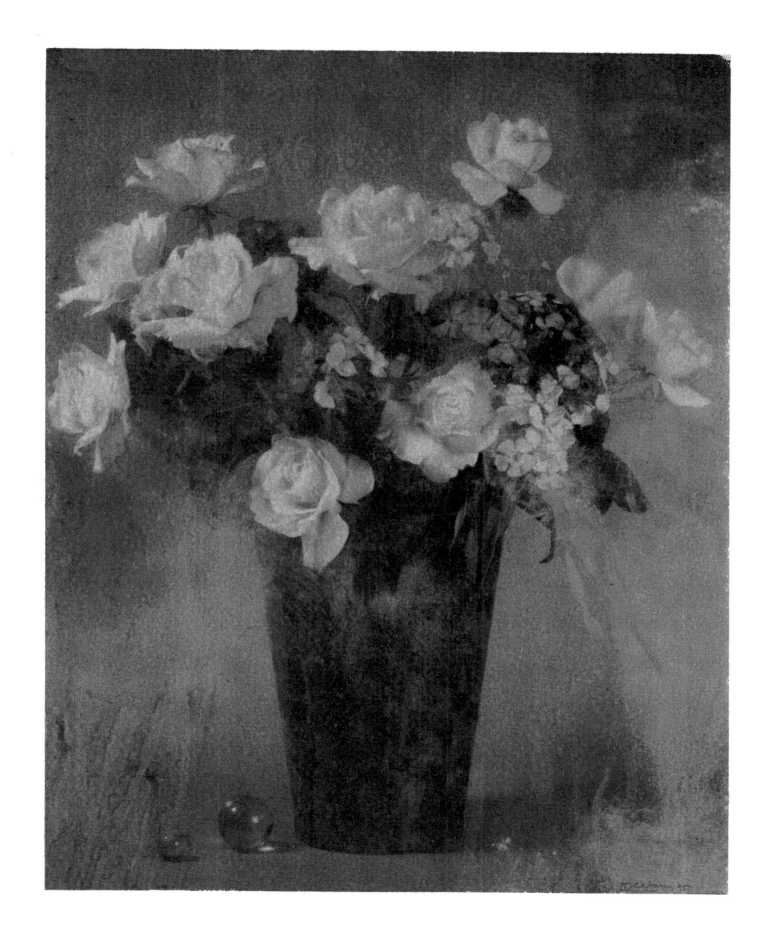

4. *Ricard*. Barcelona, España 1995

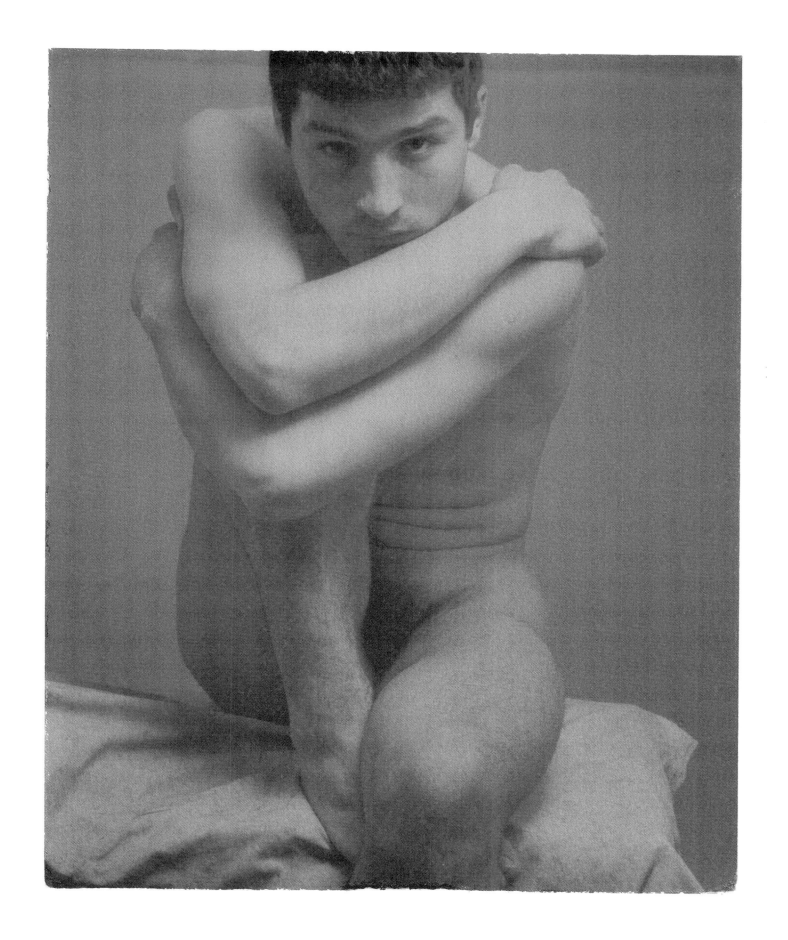

5. *L'abraçada*. Barcelona, España 1995

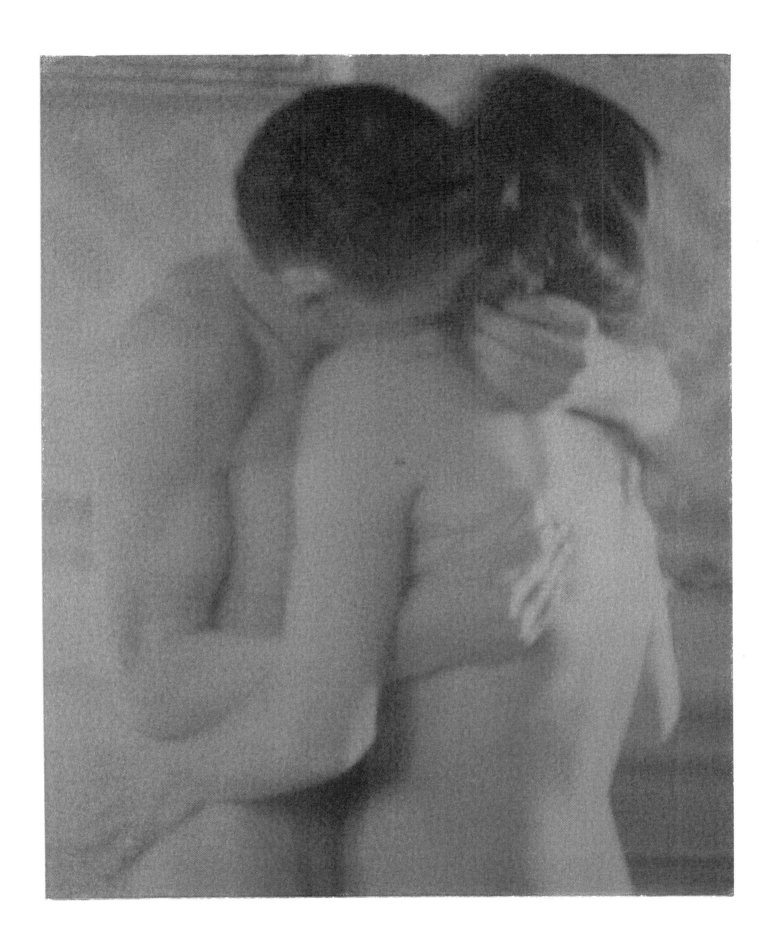

6. *Isabelle*. Barcelona, España 1990/1995

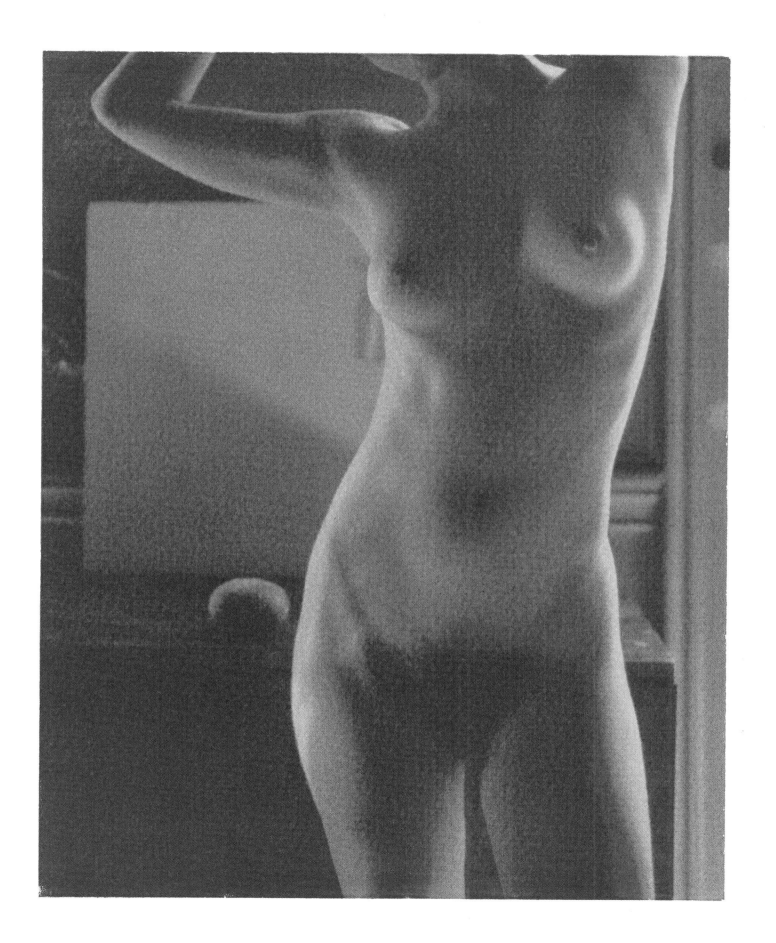

7. *Nu*. Barcelona, España 1988/1994

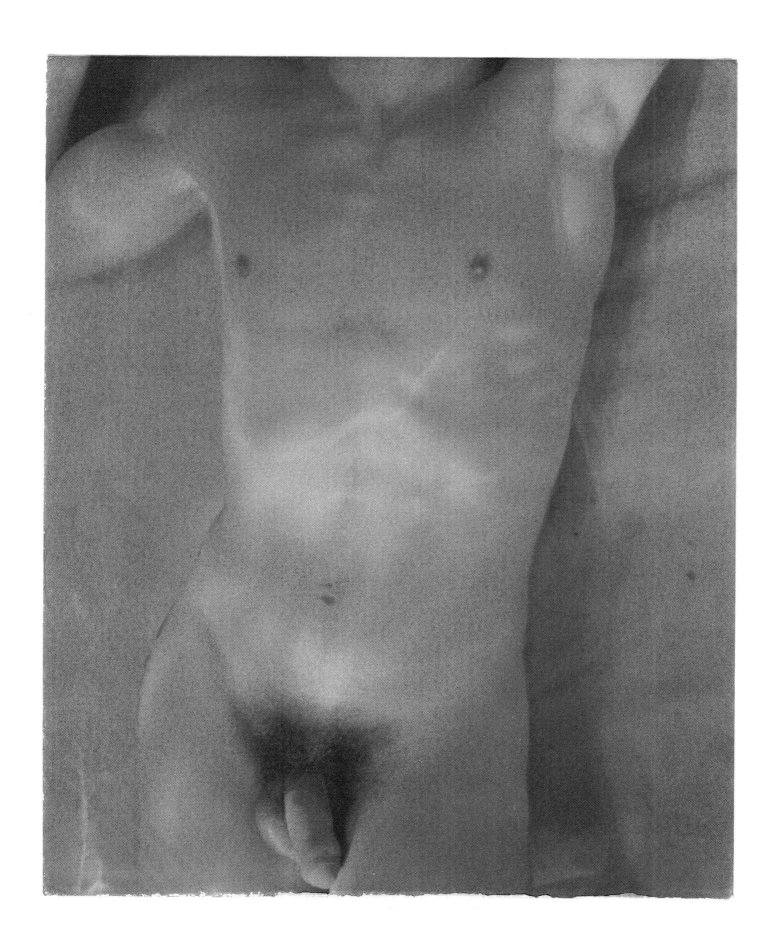

8. *Oliver*. Barcelona, España 1994

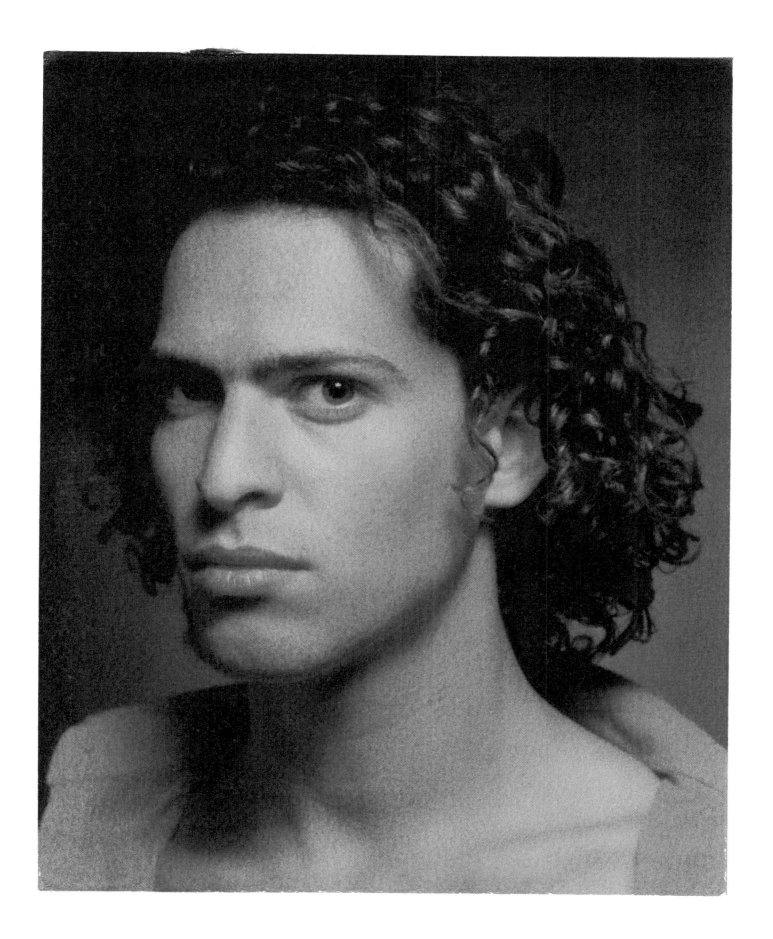

9. *Carole*. Barcelona, España 1997

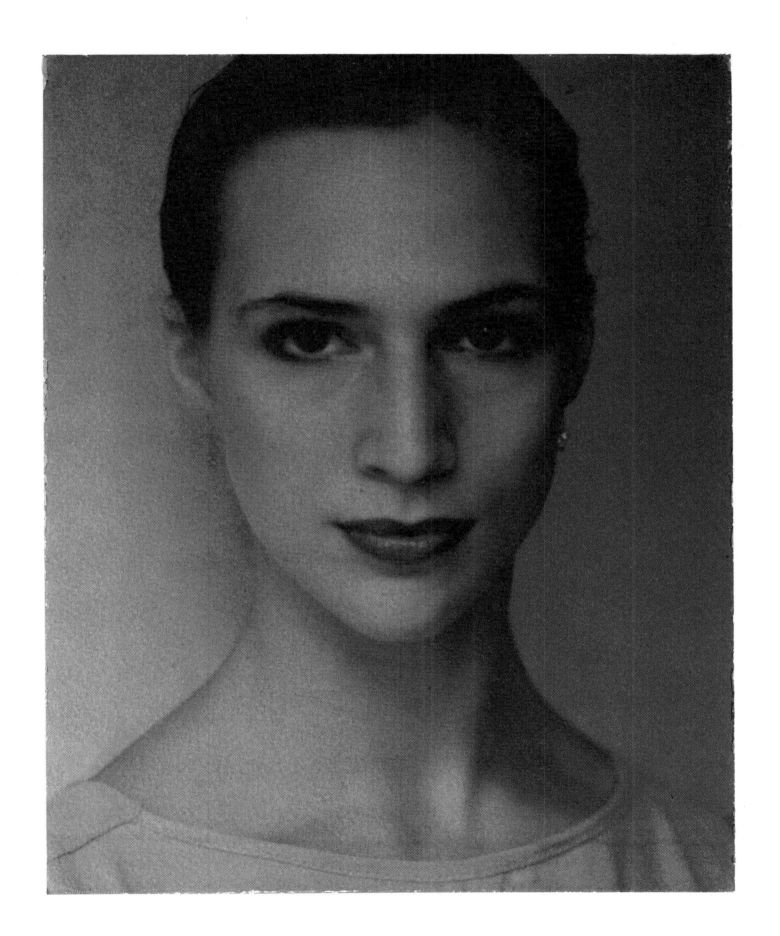

10. *Lázaro*. La Habana, Cuba 1996

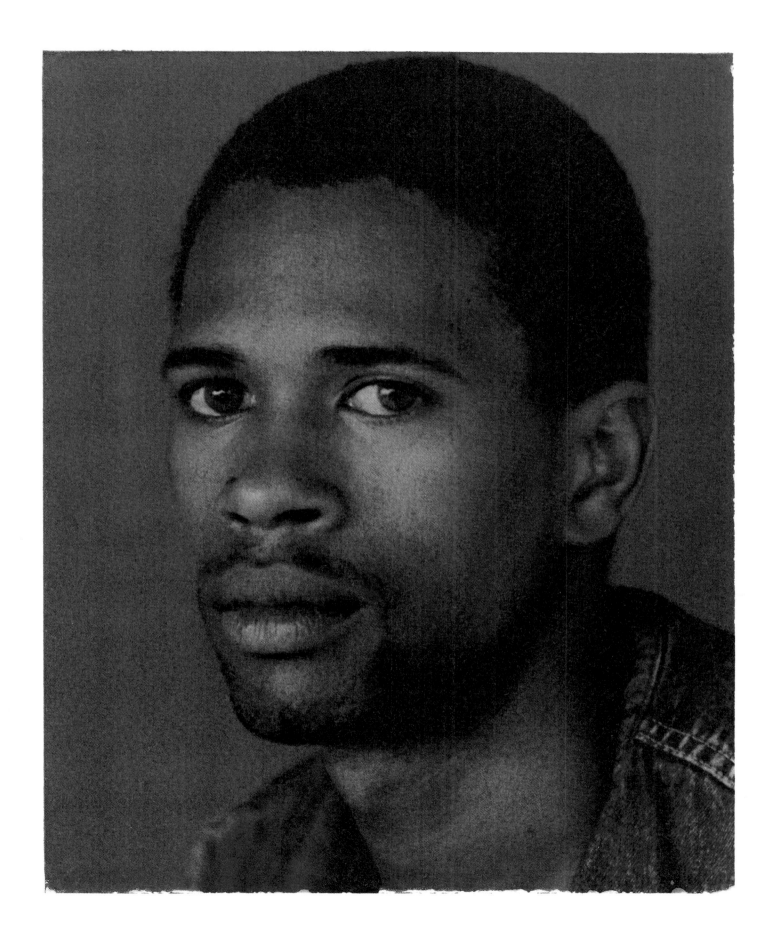

11. *Víctor.* Río Caribe, Venezuela 1996

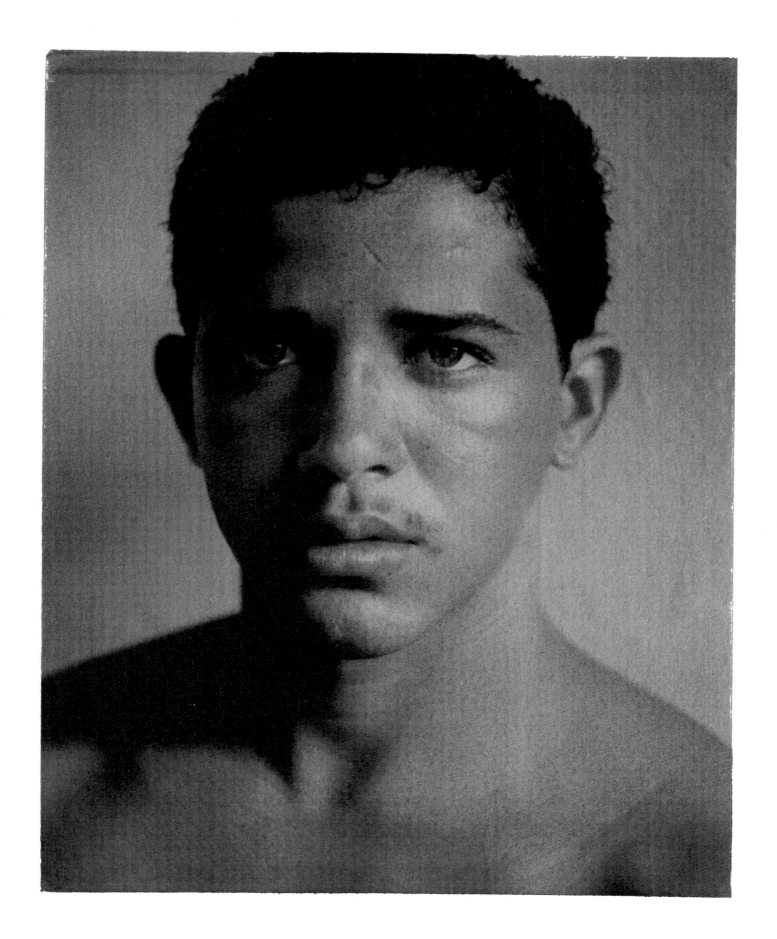

12. *David*. Isla Margarita, Venezuela 1996

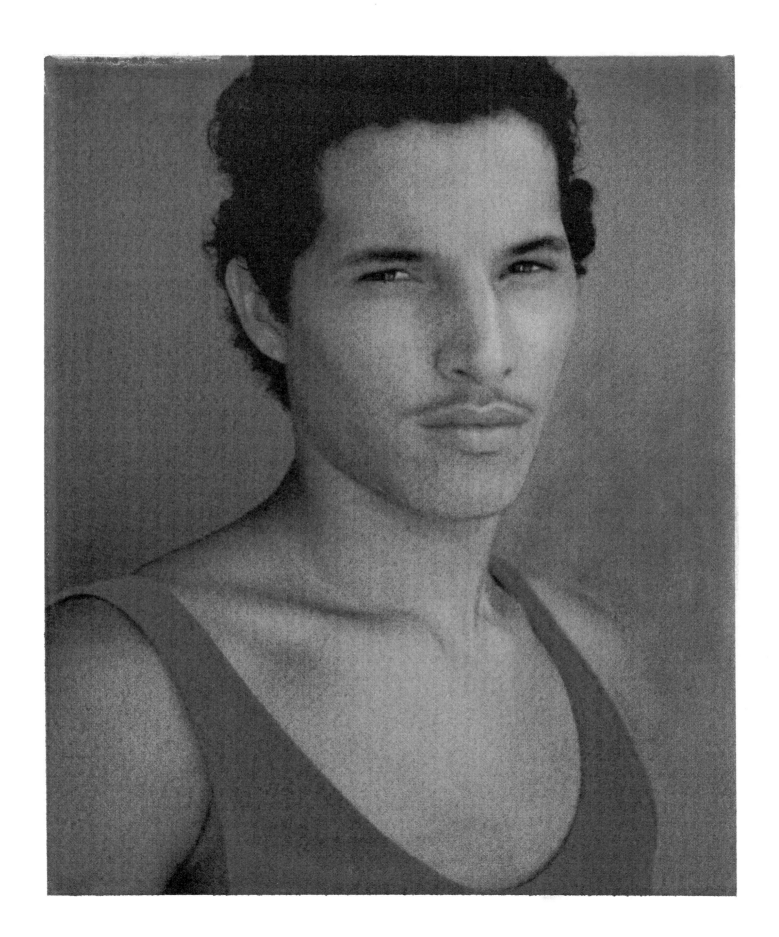

13. *La Magrana*. Barcelona, España 1995/1996

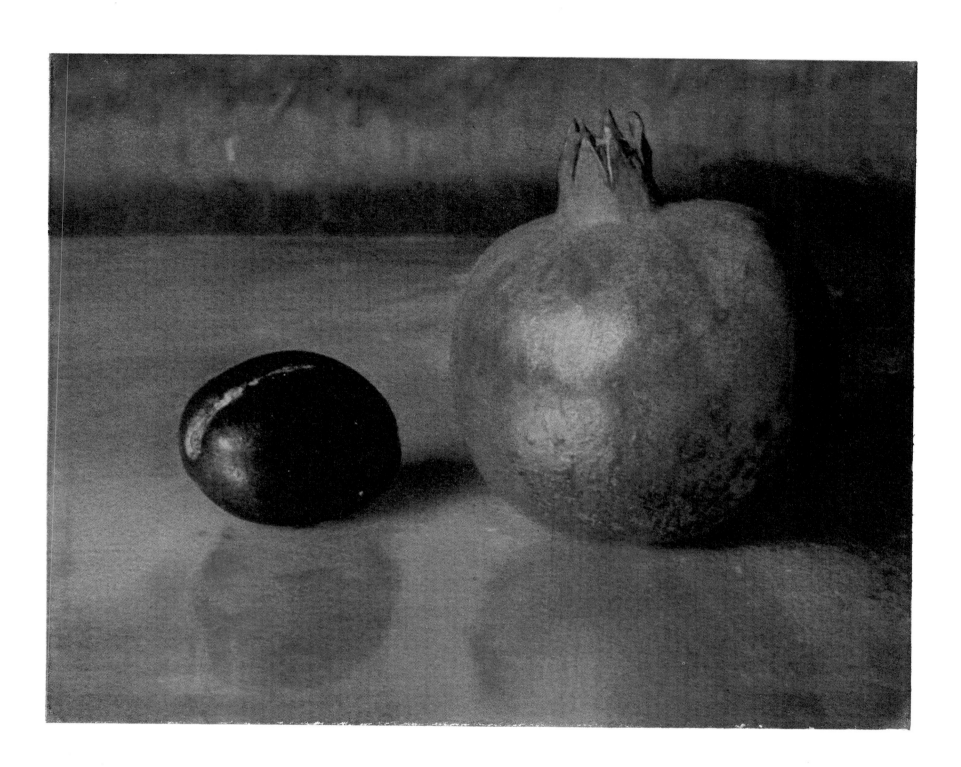

14. *Figues*. Barcelona, España 1995/1996

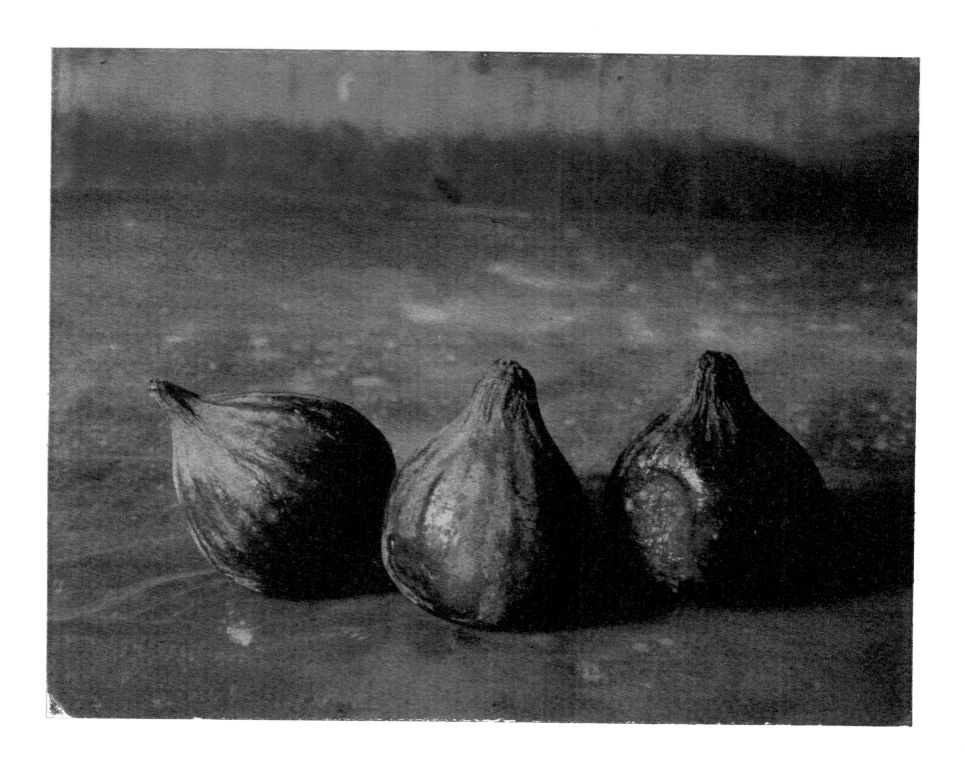

15. *José Ramón*. Río Caribe, Venezuela 1996

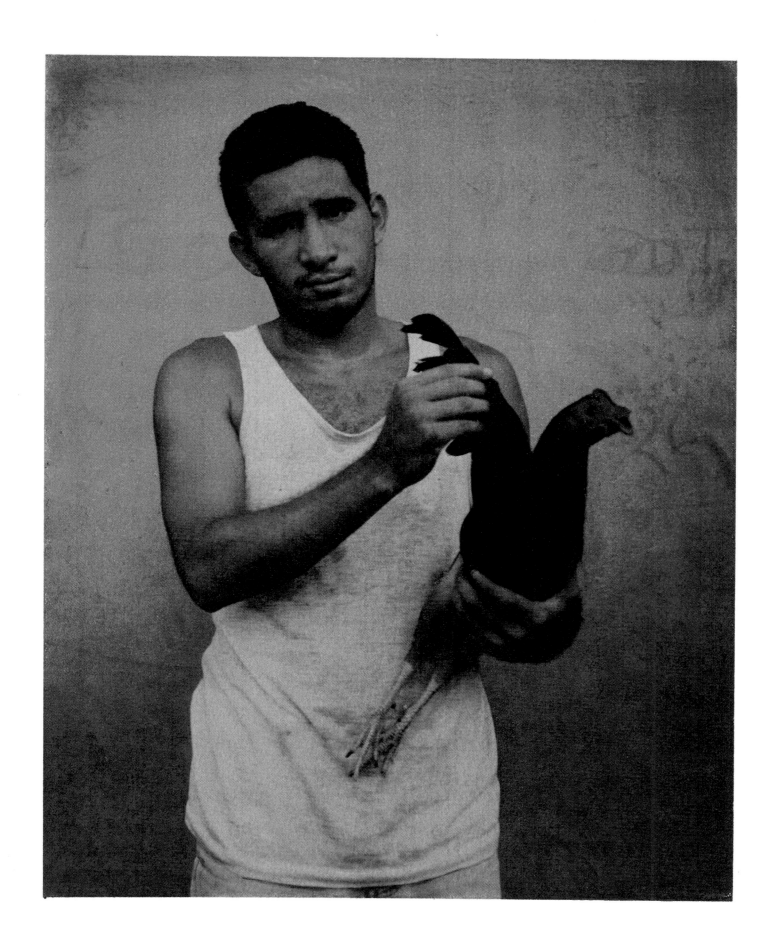

16. *Chucha*. Uquire, Venezuela 1996

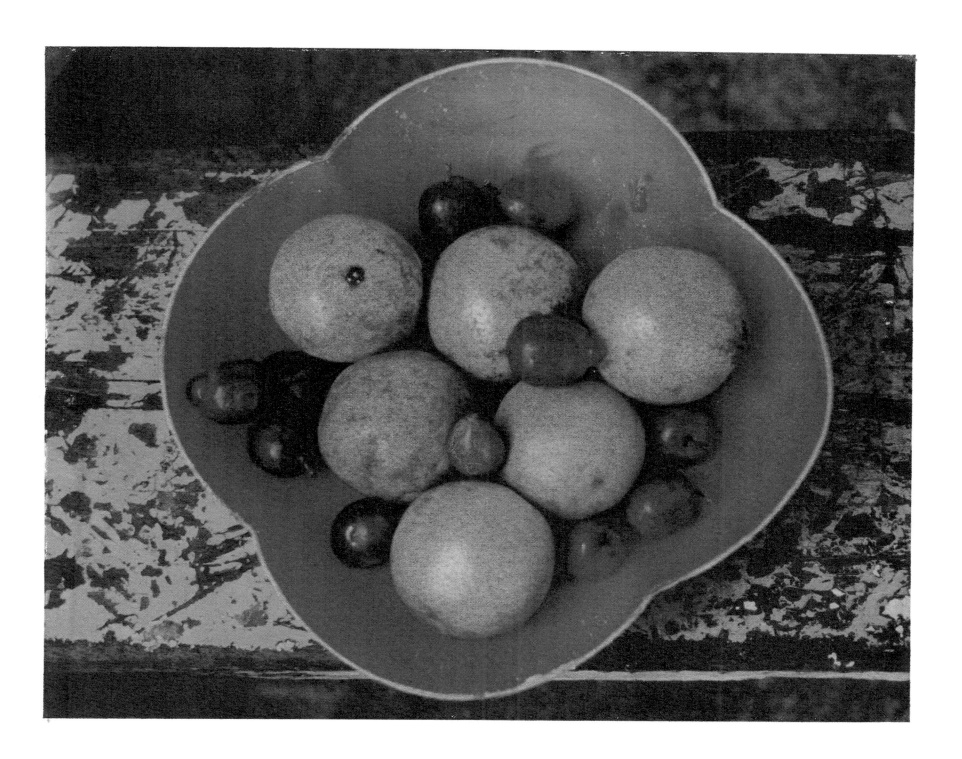

20. *Eugenia*. Baracoa, Cuba 1997

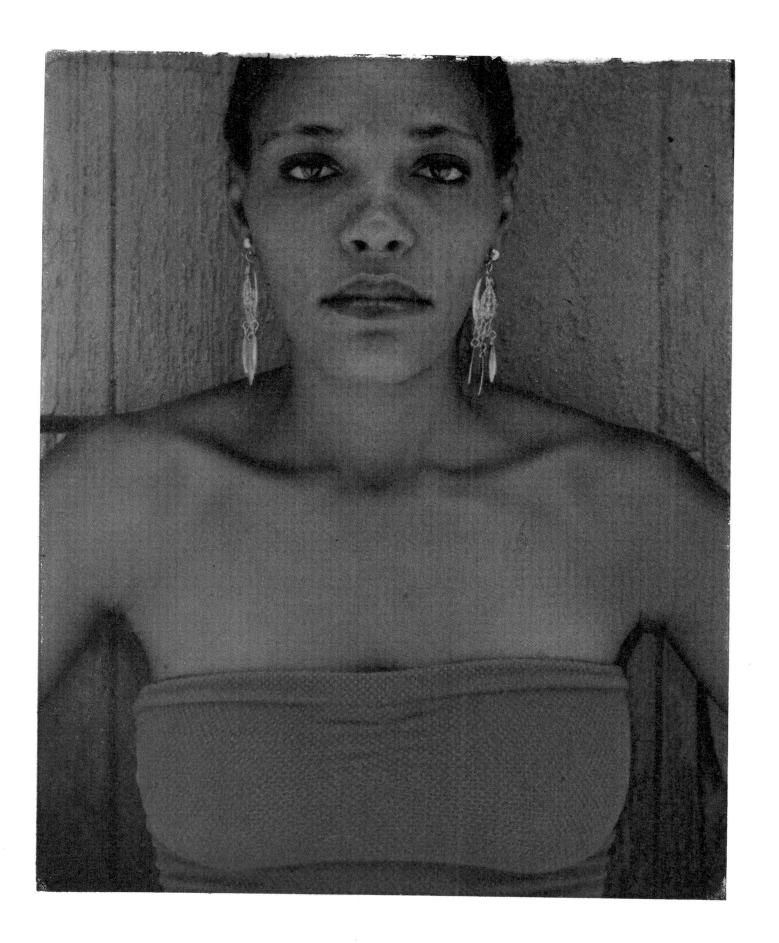

21. Isla Margarita, Venezuela 1996

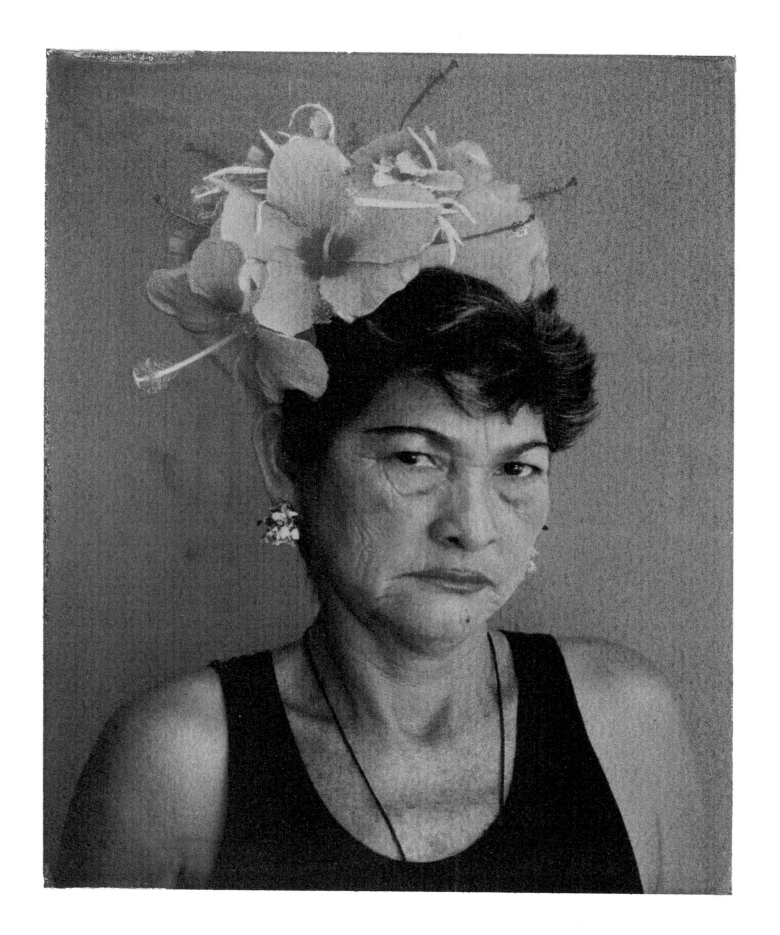

22. Ghana 1995

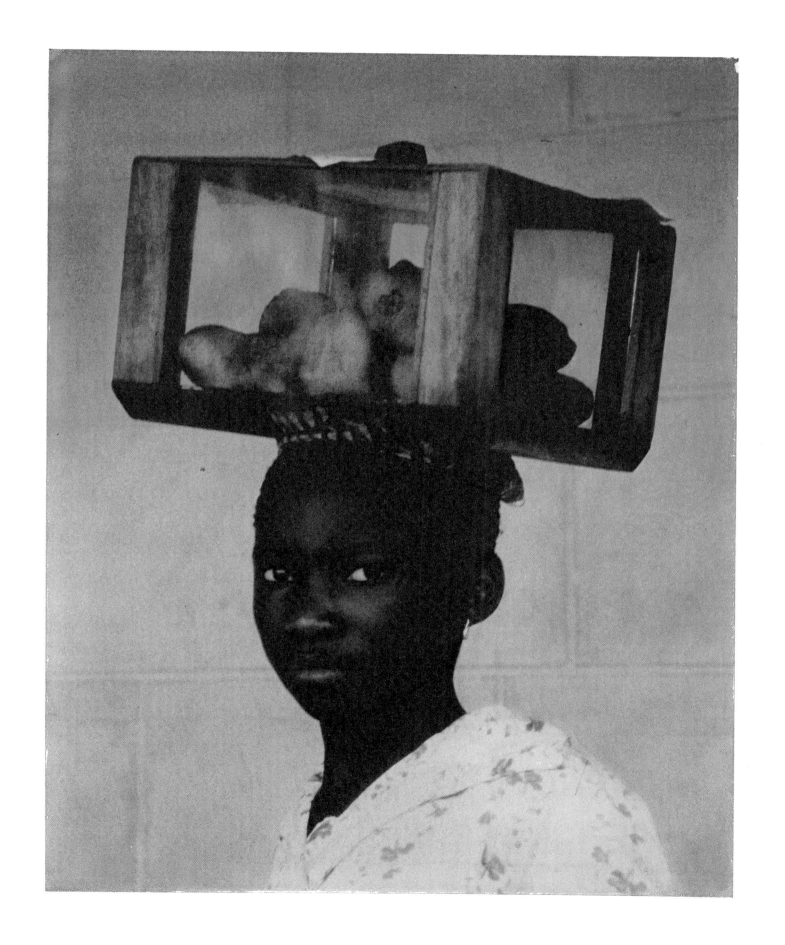

23. Kumasi, Ghana 1995

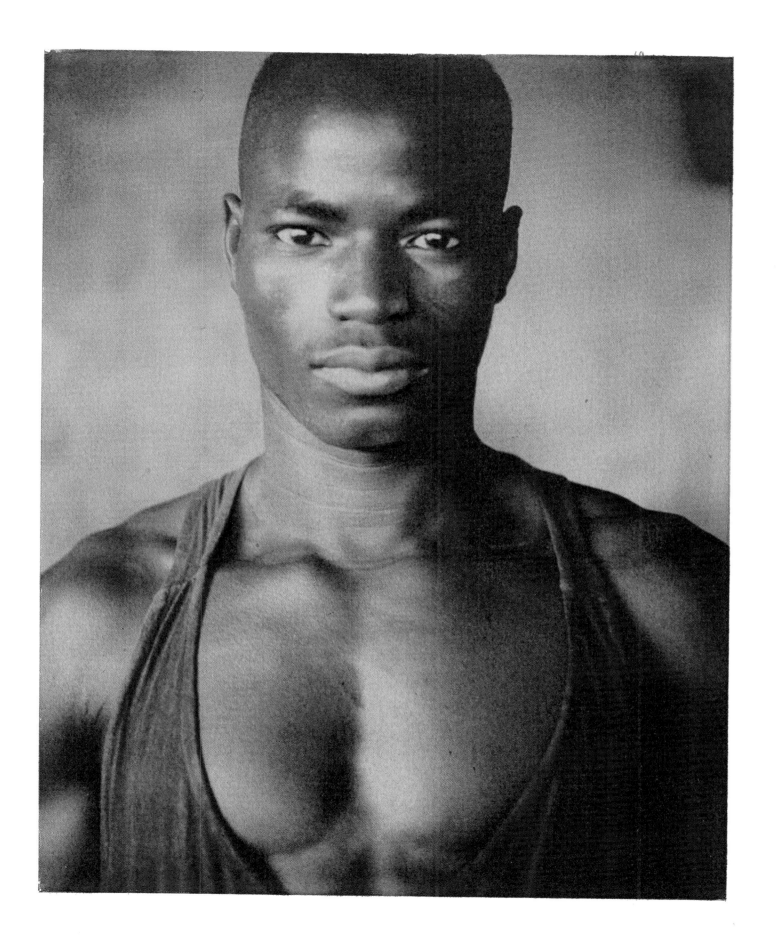

24. Elmina, Ghana 1995

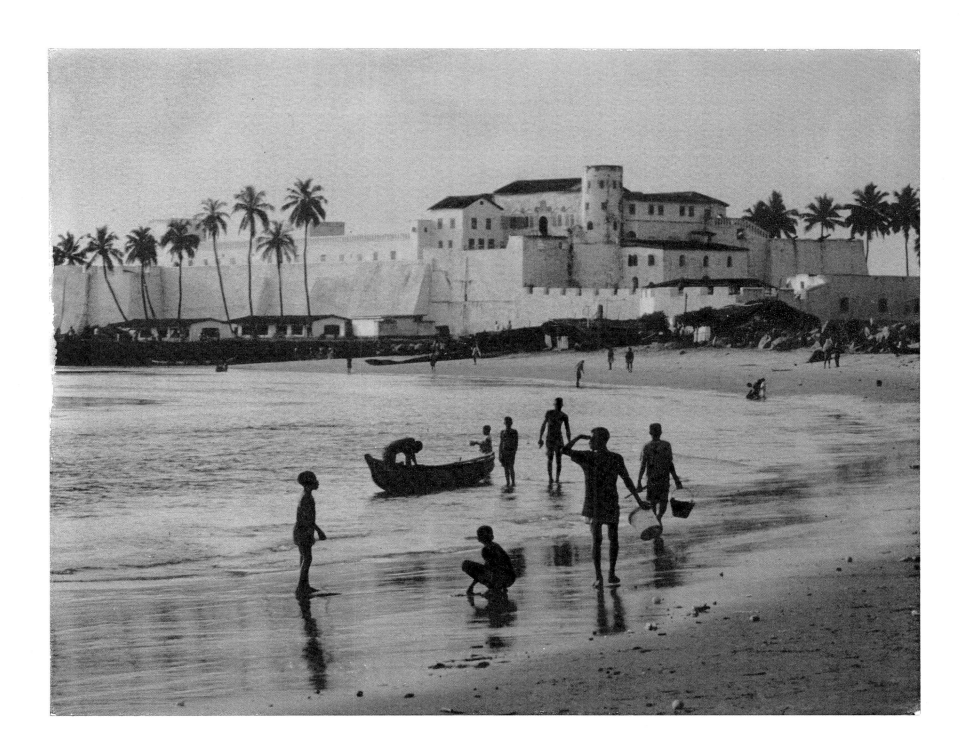

25. Isla Margarita, Venezuela 1996

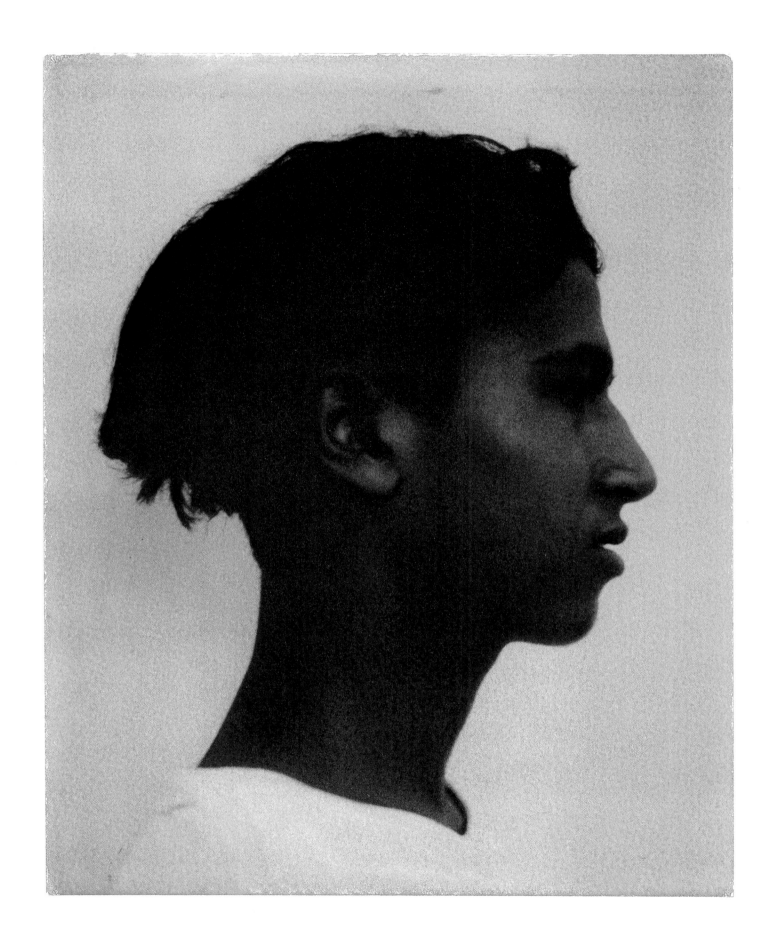

26. Delhi, India 1996

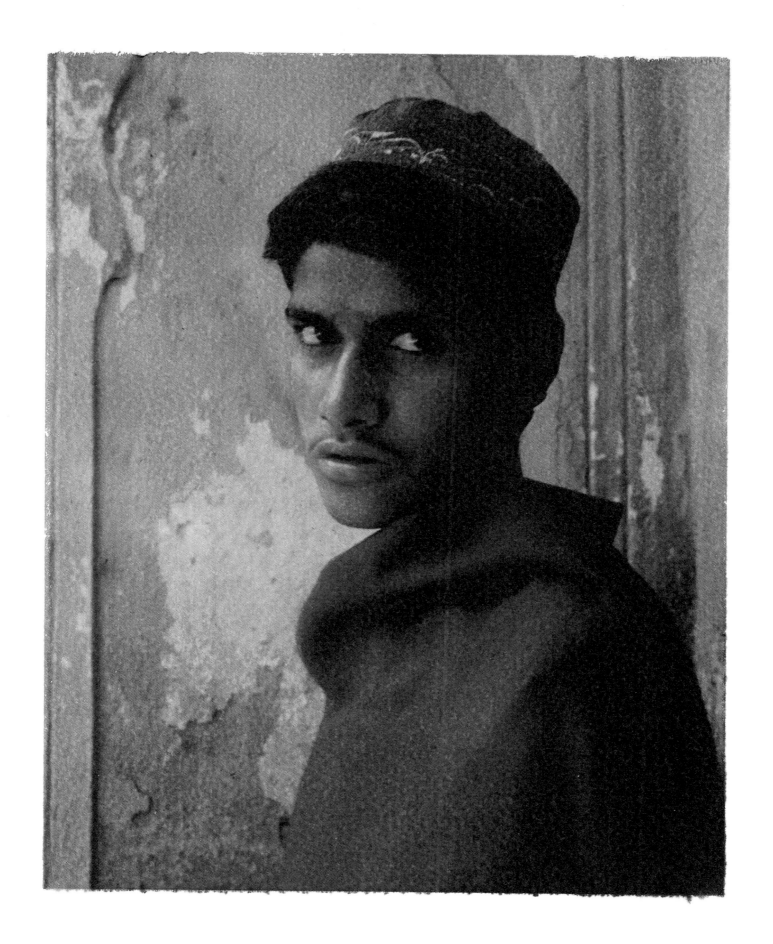

27. Jaisalmer, India 1996

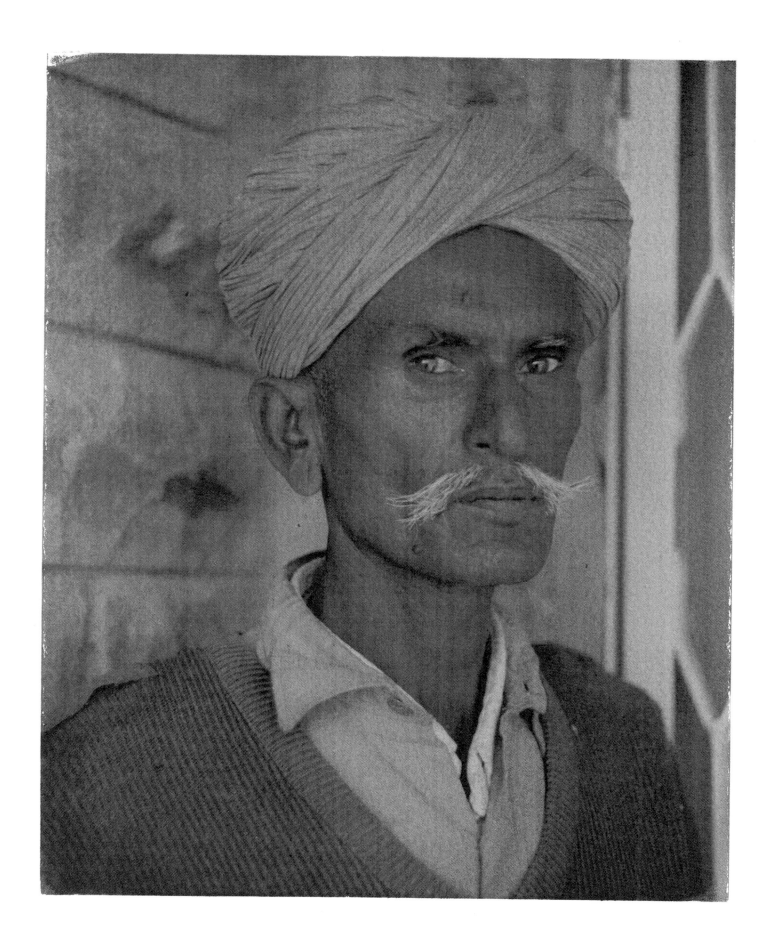

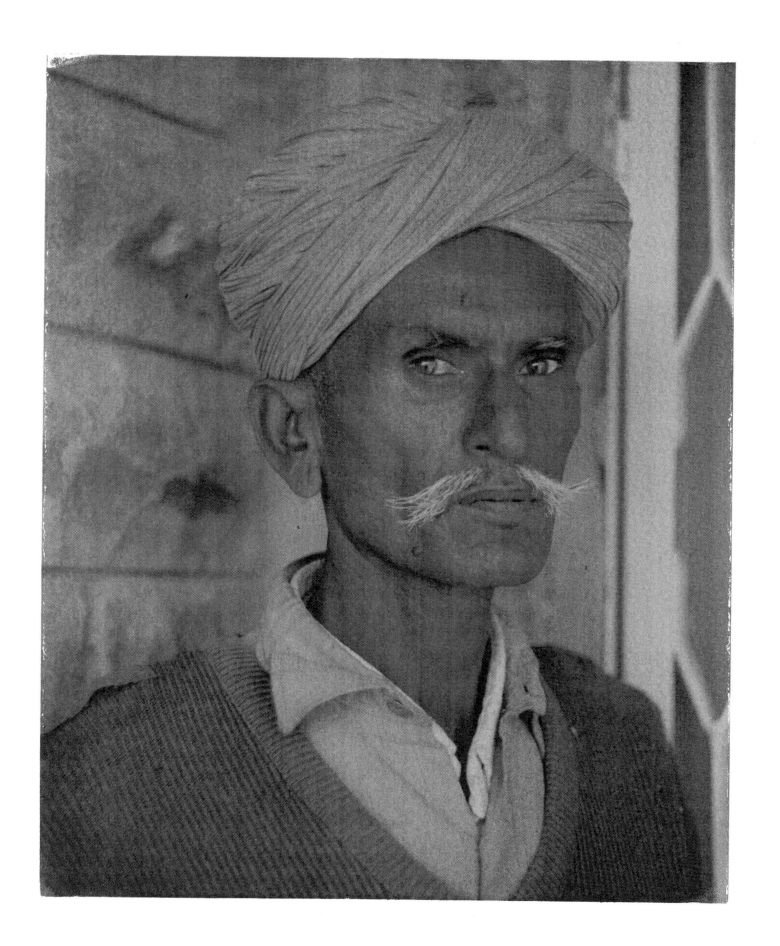

28. *Amar*. Jaisalmer, India 1996

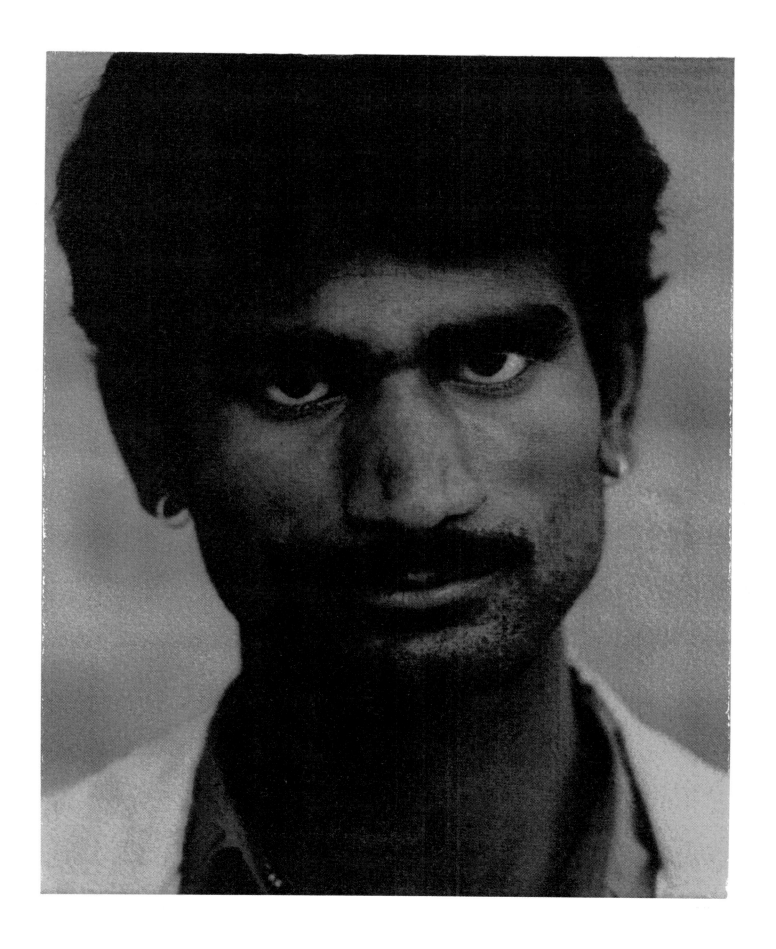

29. La Habana, Cuba 1997

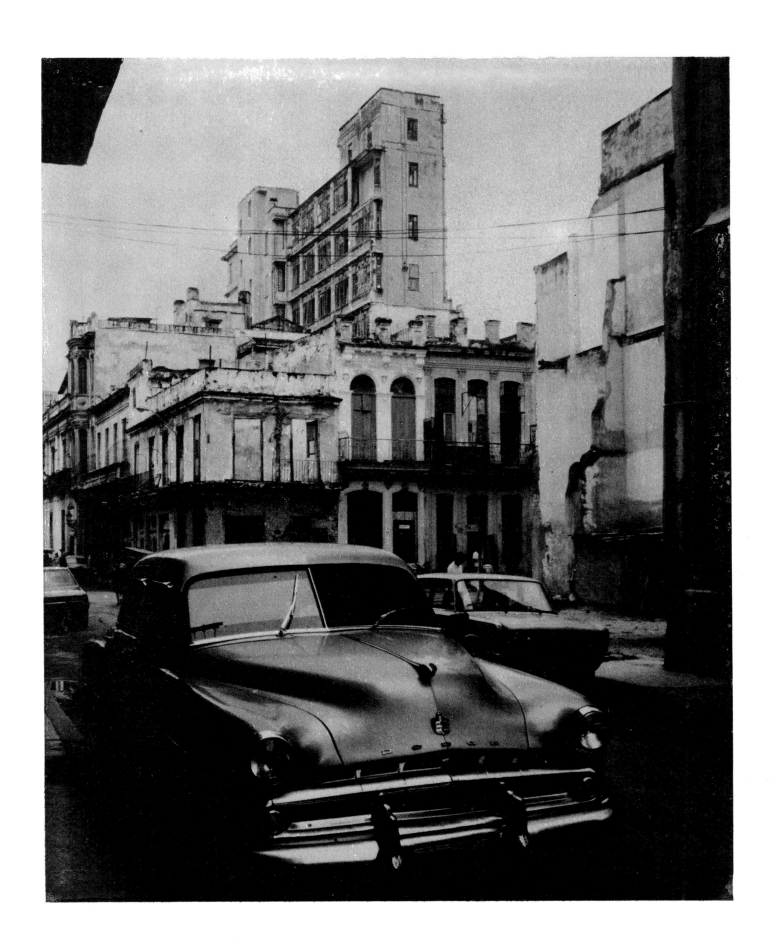

30. Mérida, México 1996

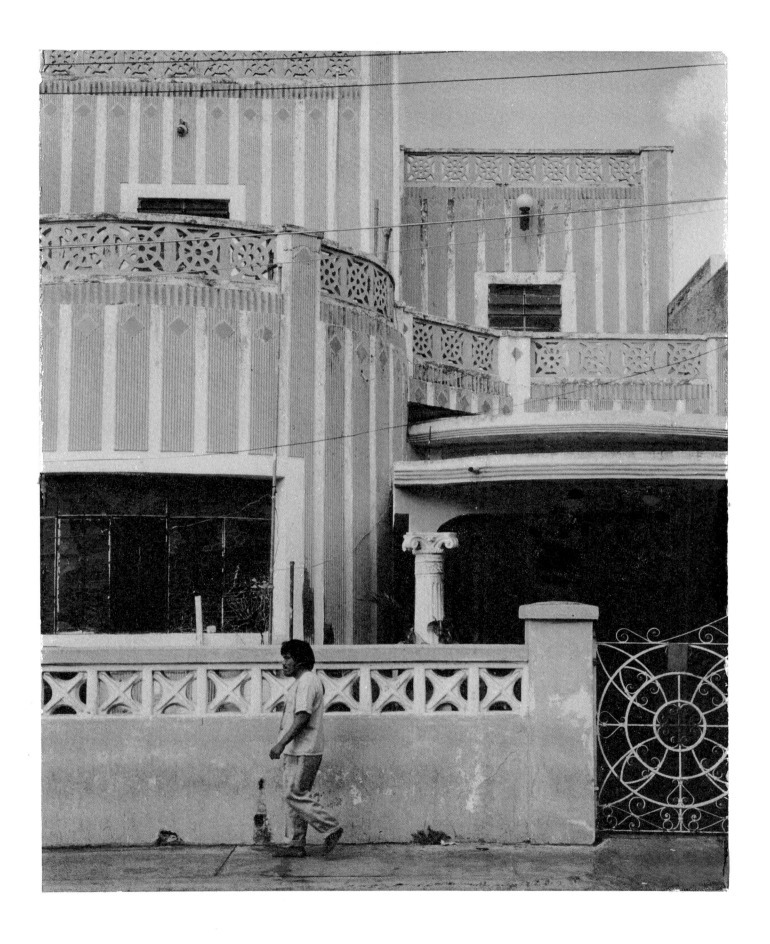

31. *Ricard*. Barcelona, España 1995

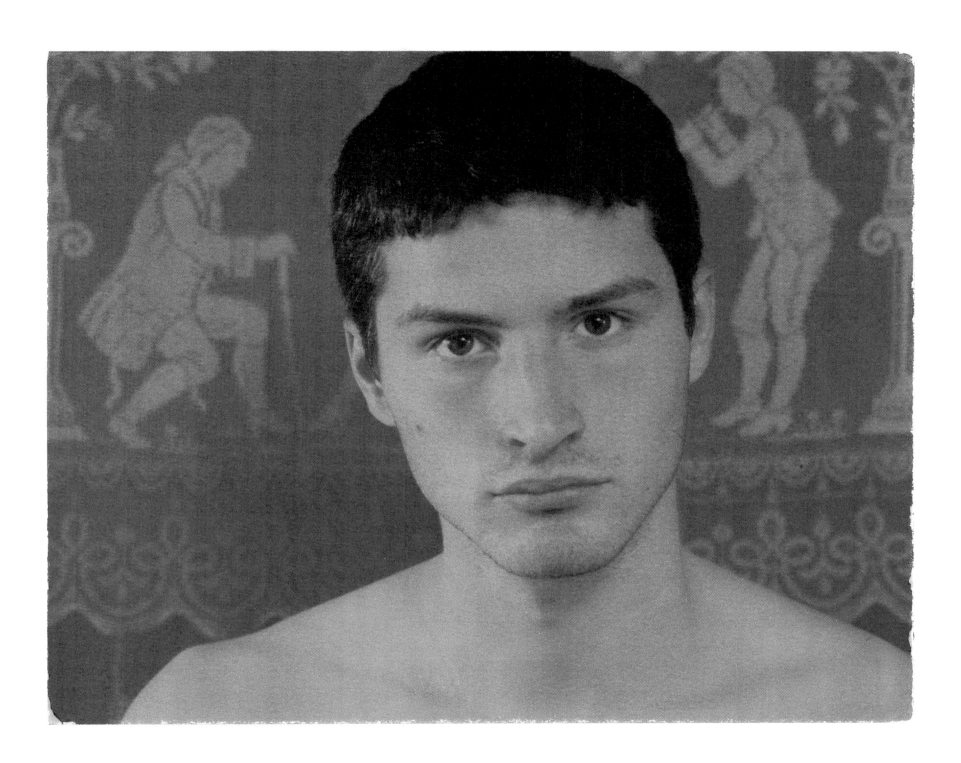

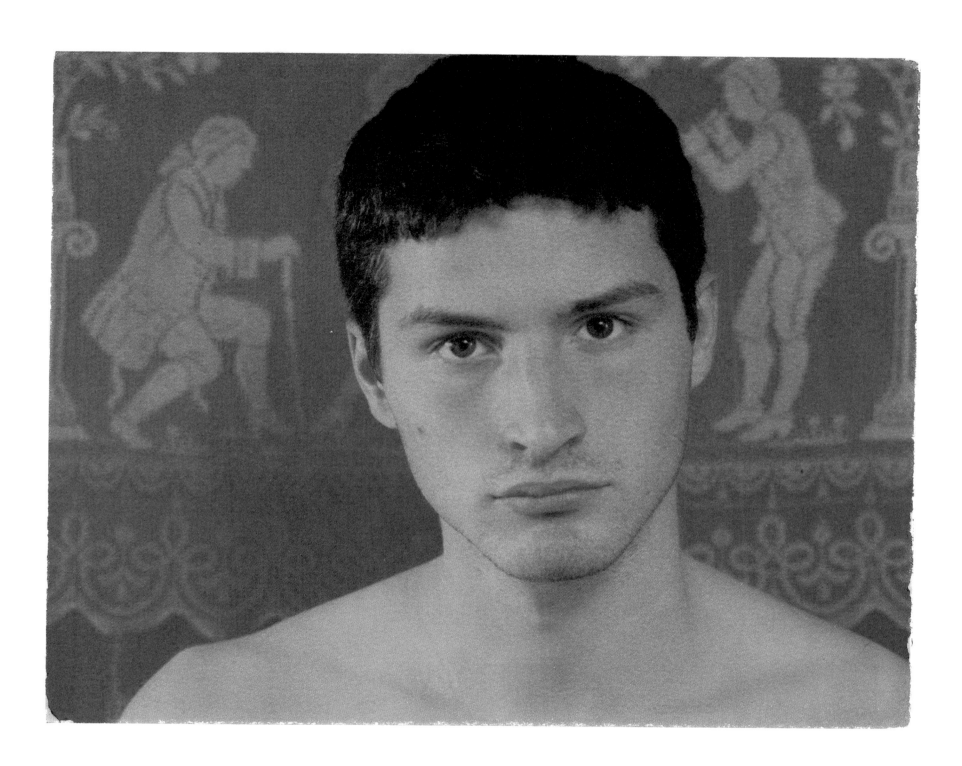

32. Barcelona, España 1995

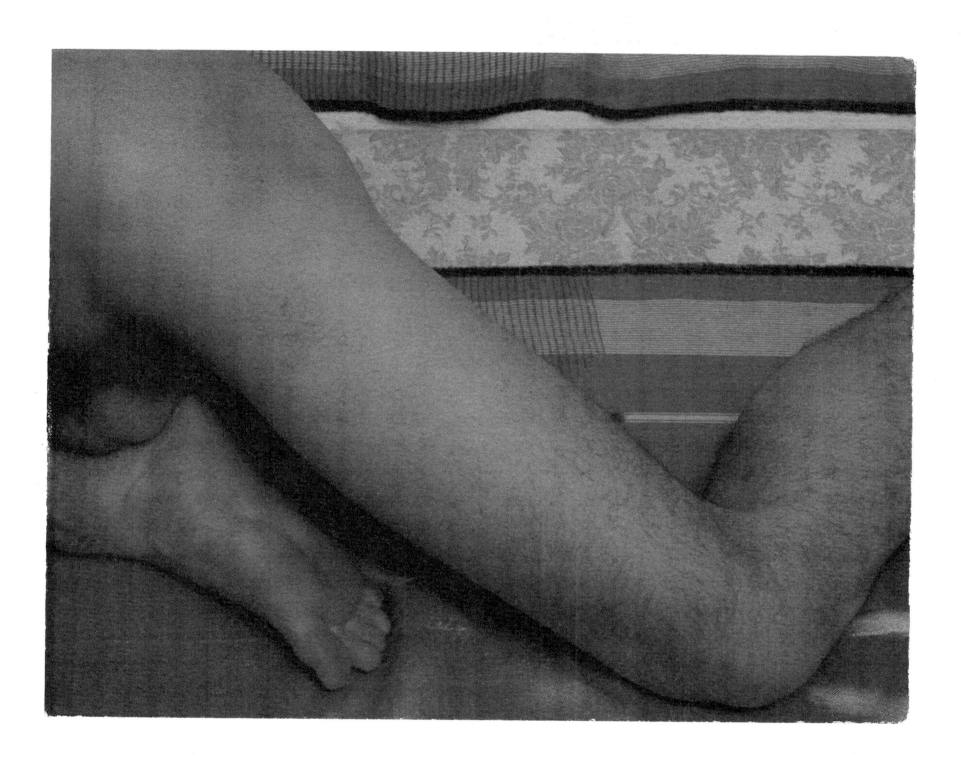

33. Barcelona, España 1995

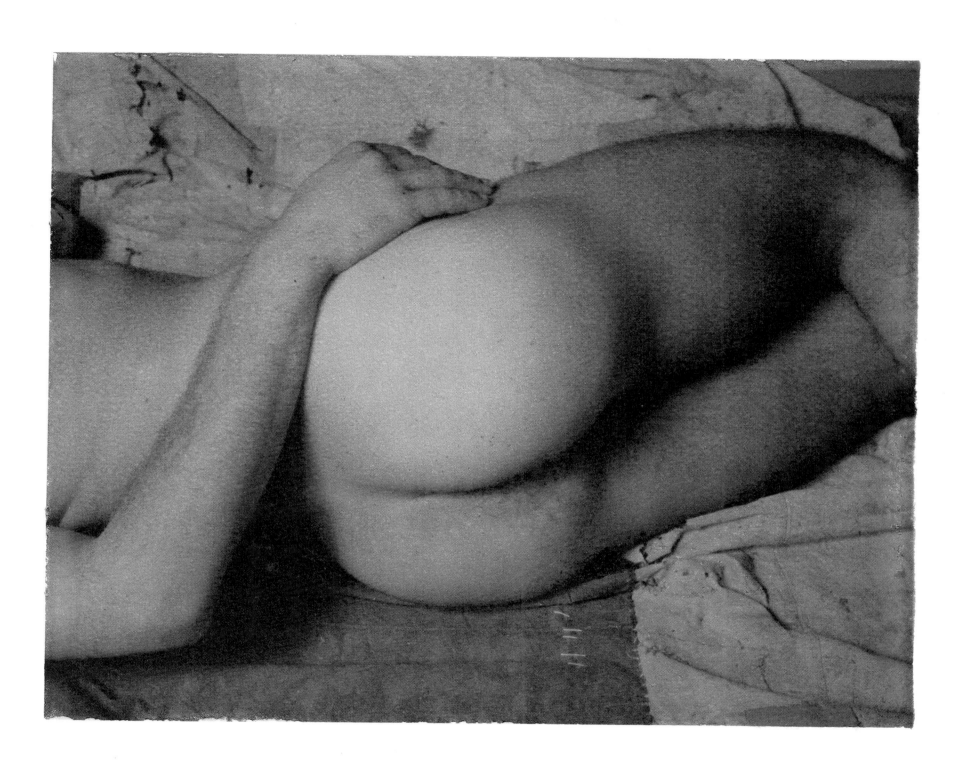

34. *Homar*. Don Pedro, Venezuela 1996

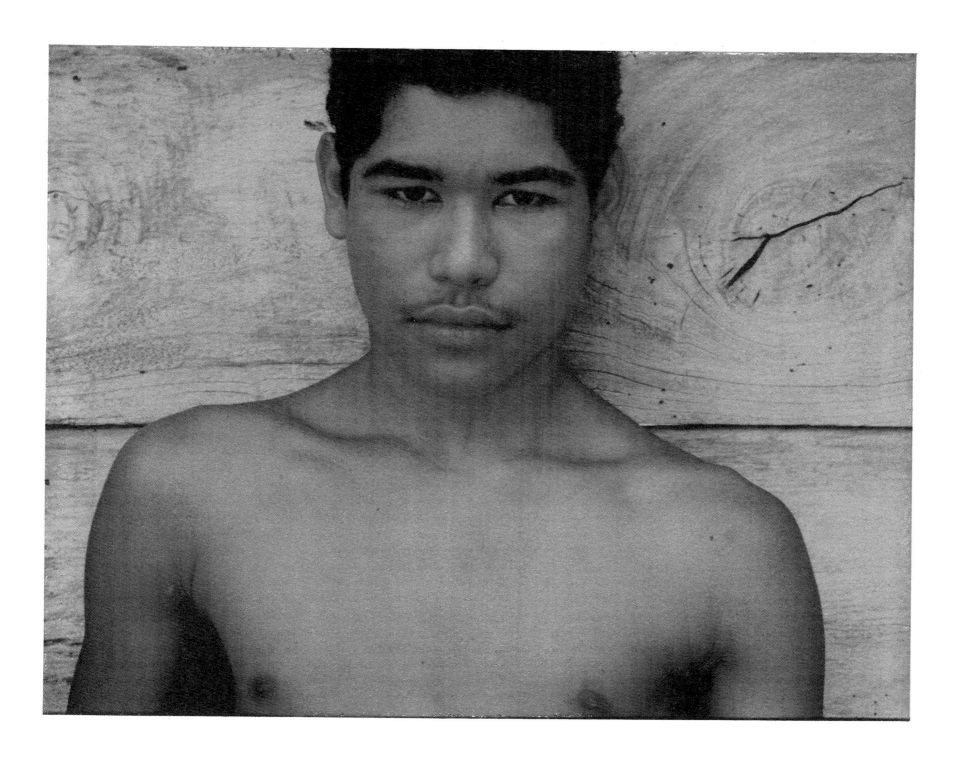

35. Barcelona, España 1989/1995

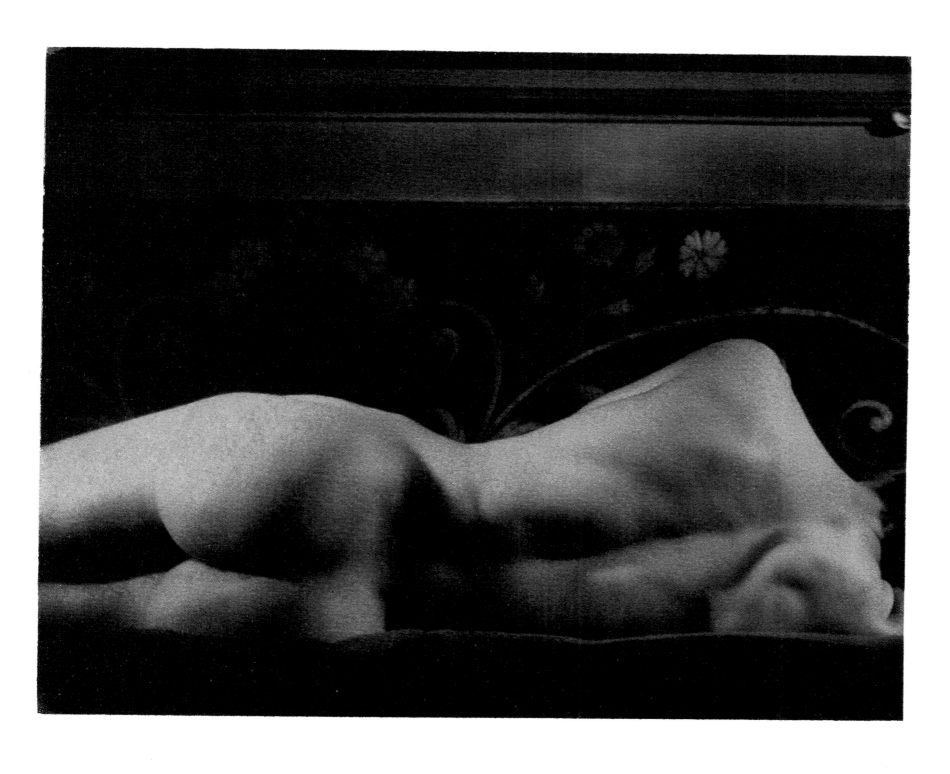

36. Barcelona, España 1995

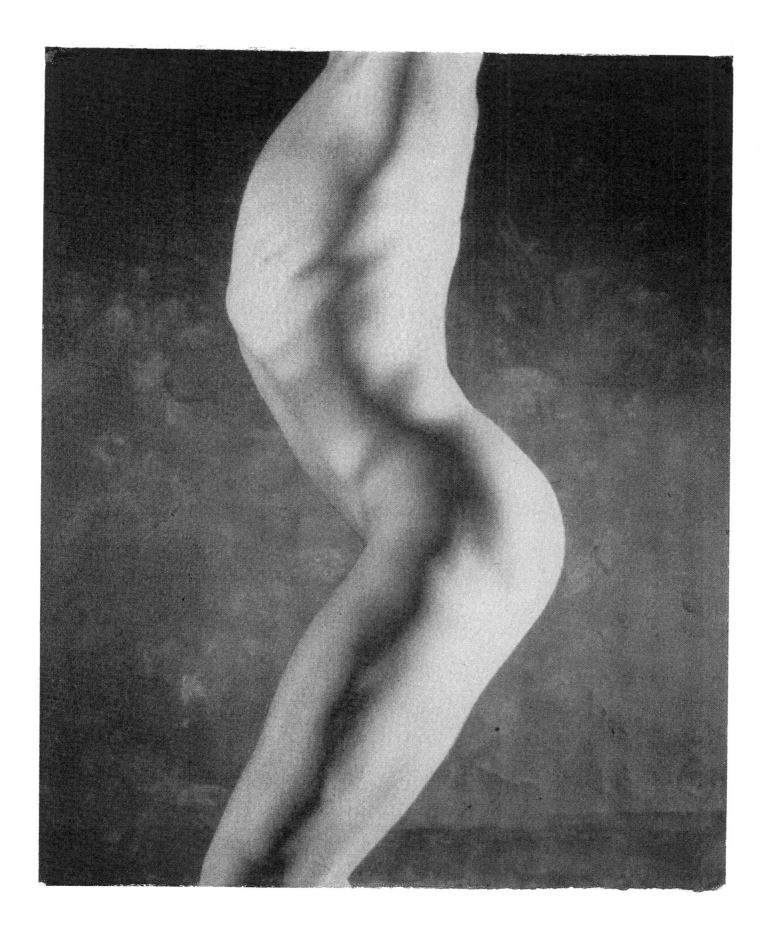

37. Barcelona, España 1987/1994

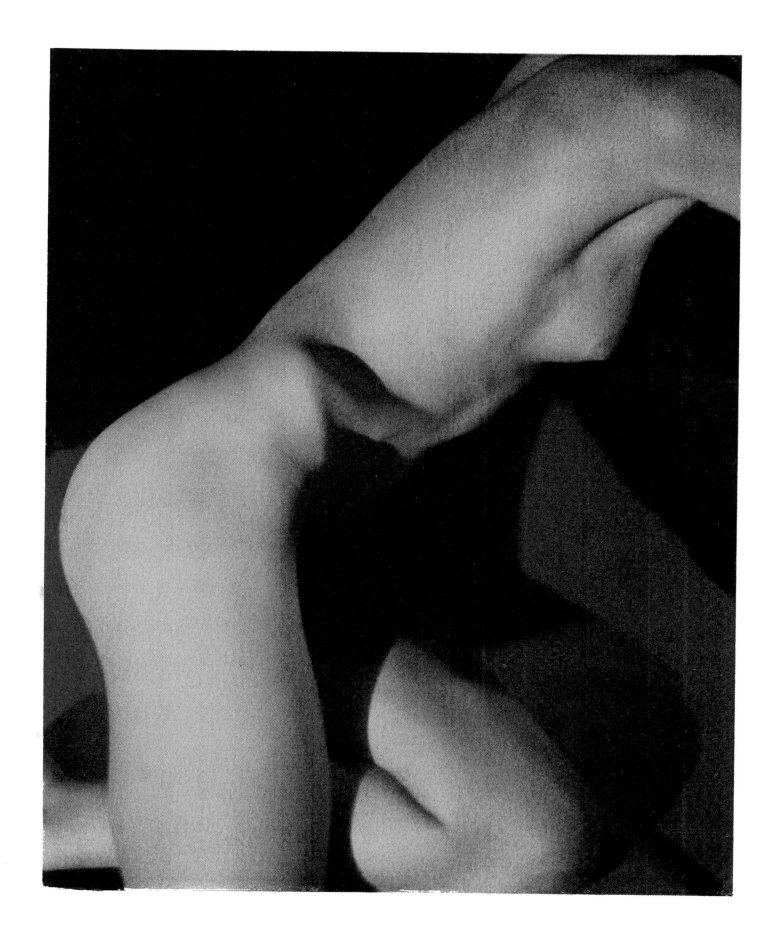

38. *Jana*. Madrid, España 1995

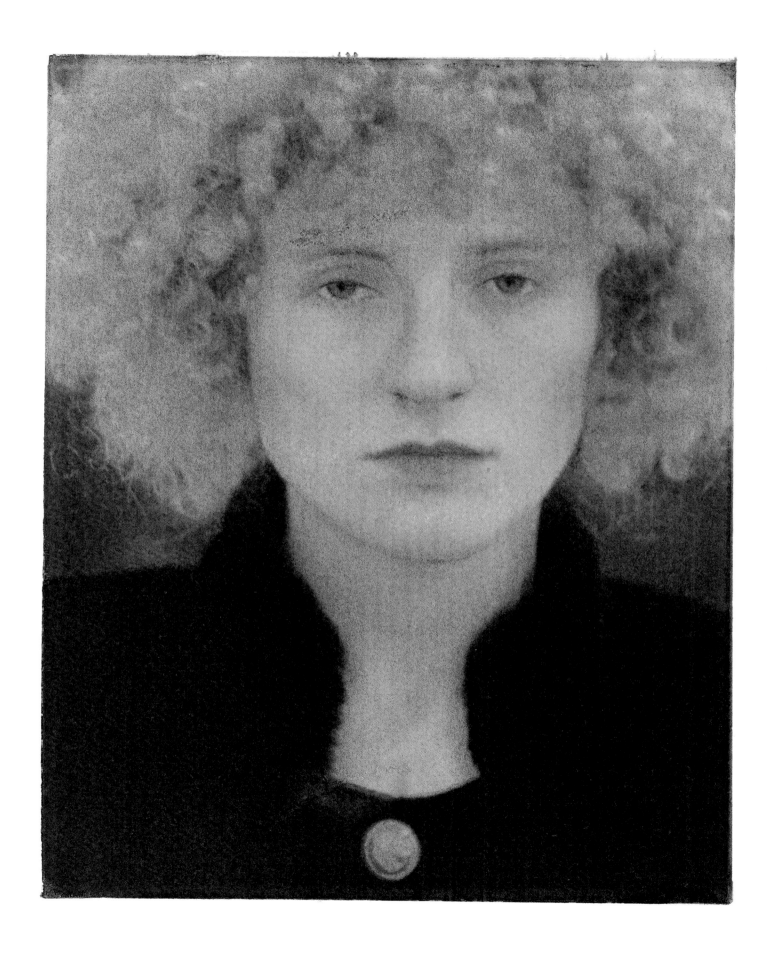

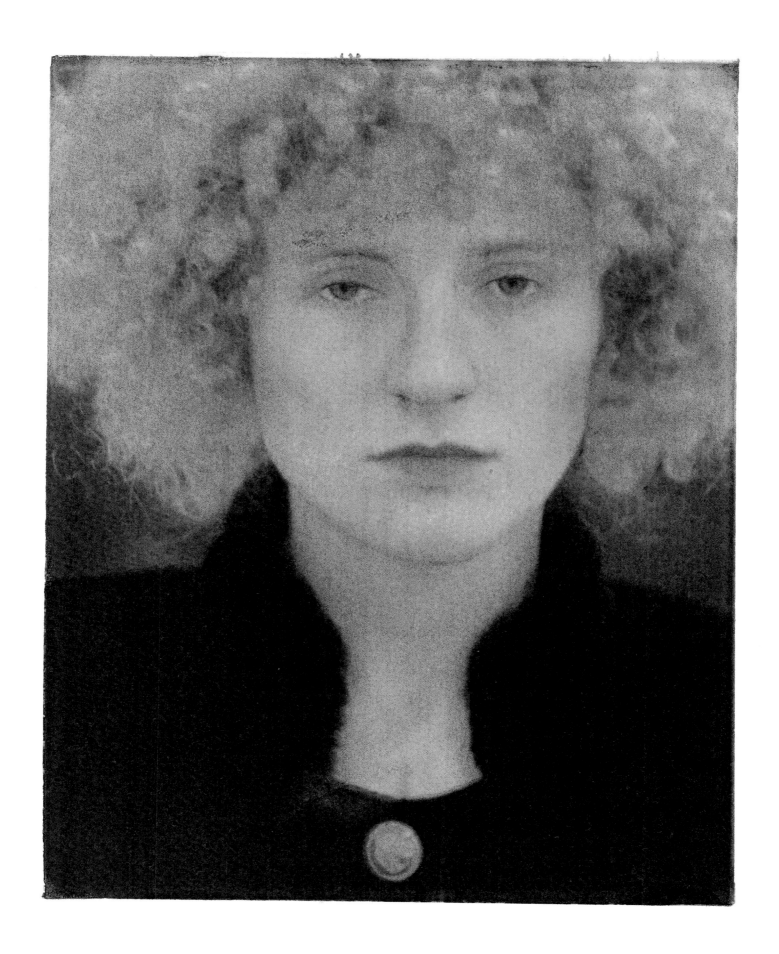

39. *Bodegó Nº 3*. Barcelona, España 1995

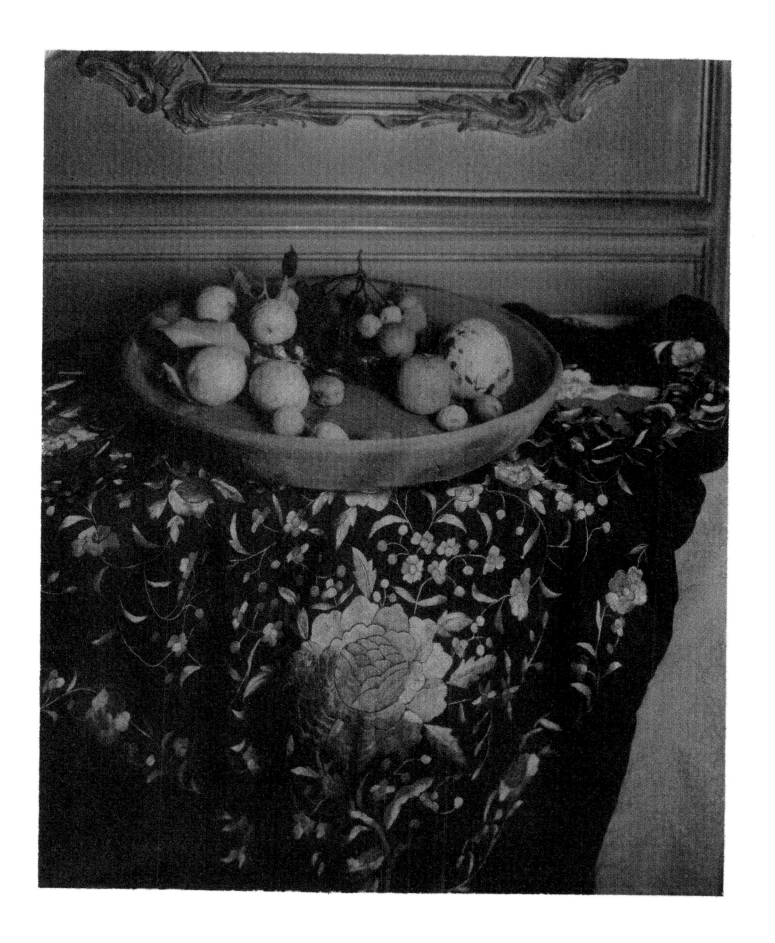

40. Roma, Italia 1995

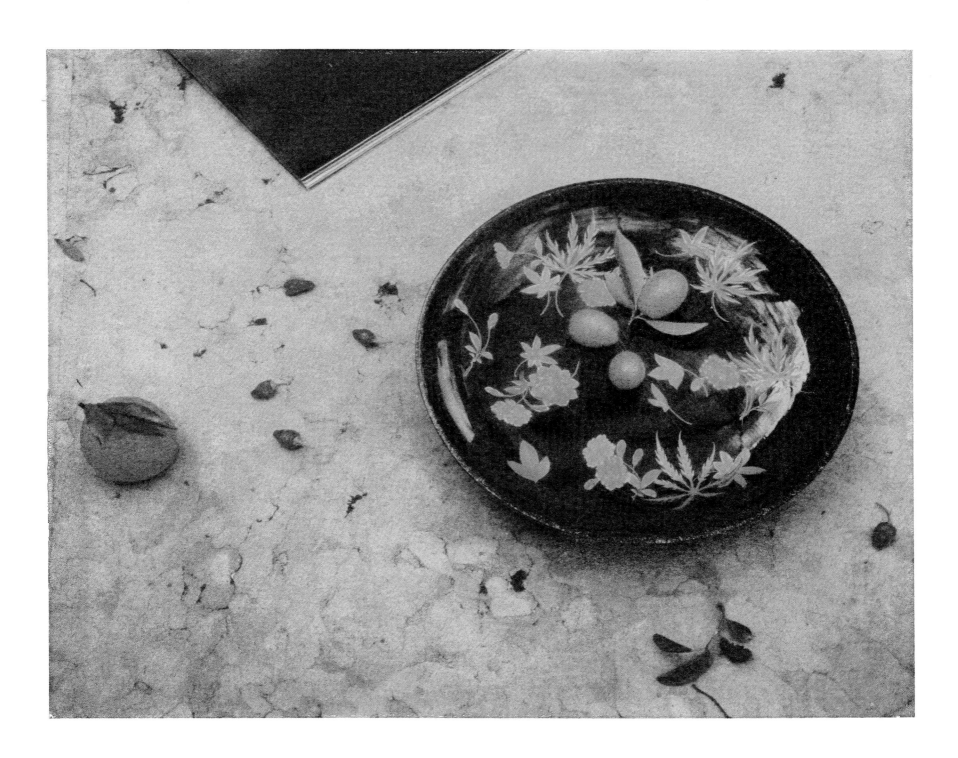

41. Roma, Italia 1995

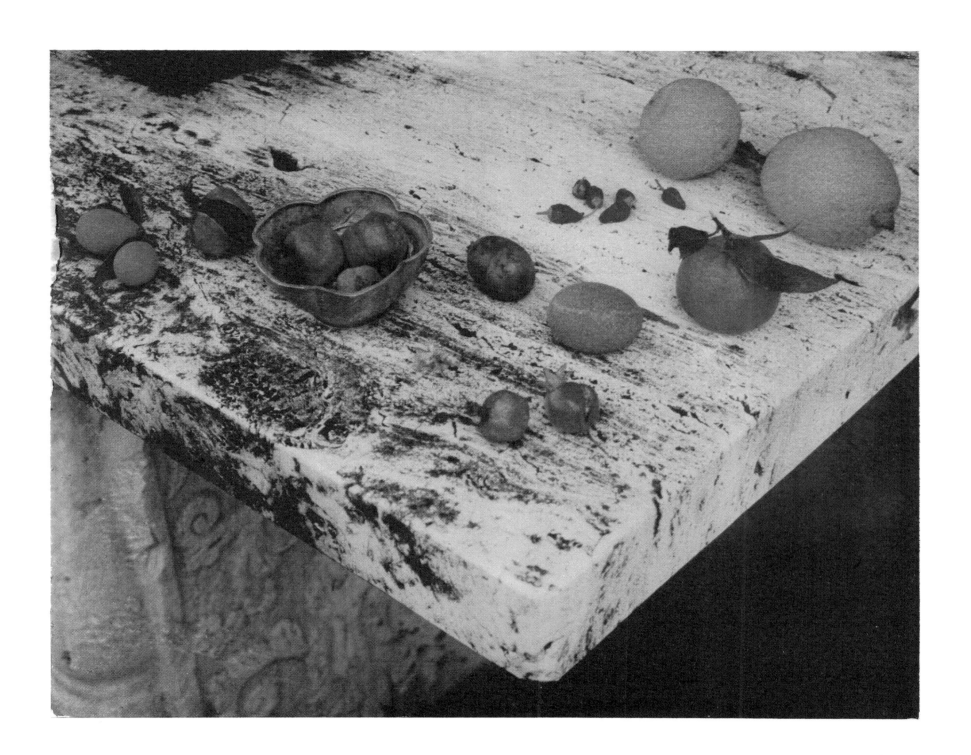

42. Roma, Italia 1995

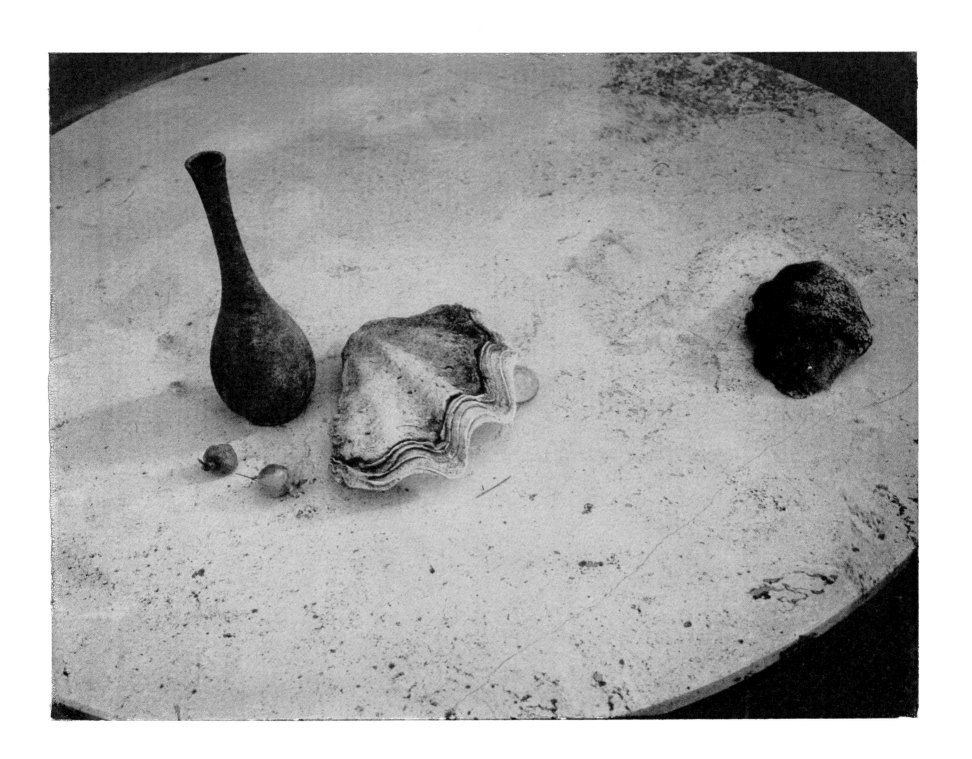

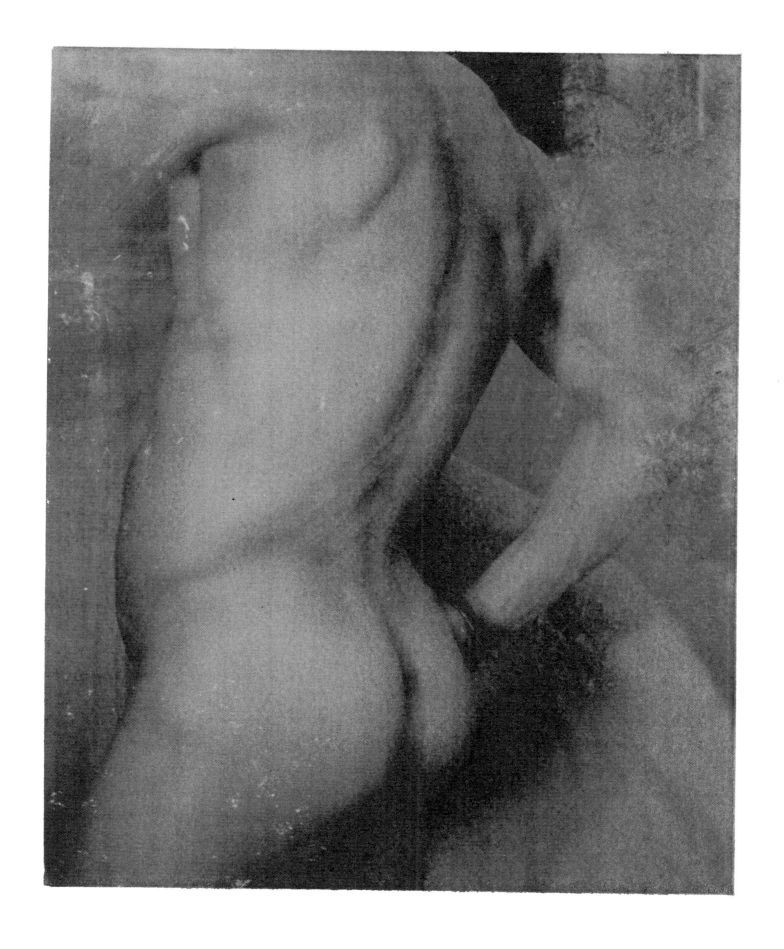

44. Barcelona, España 1997

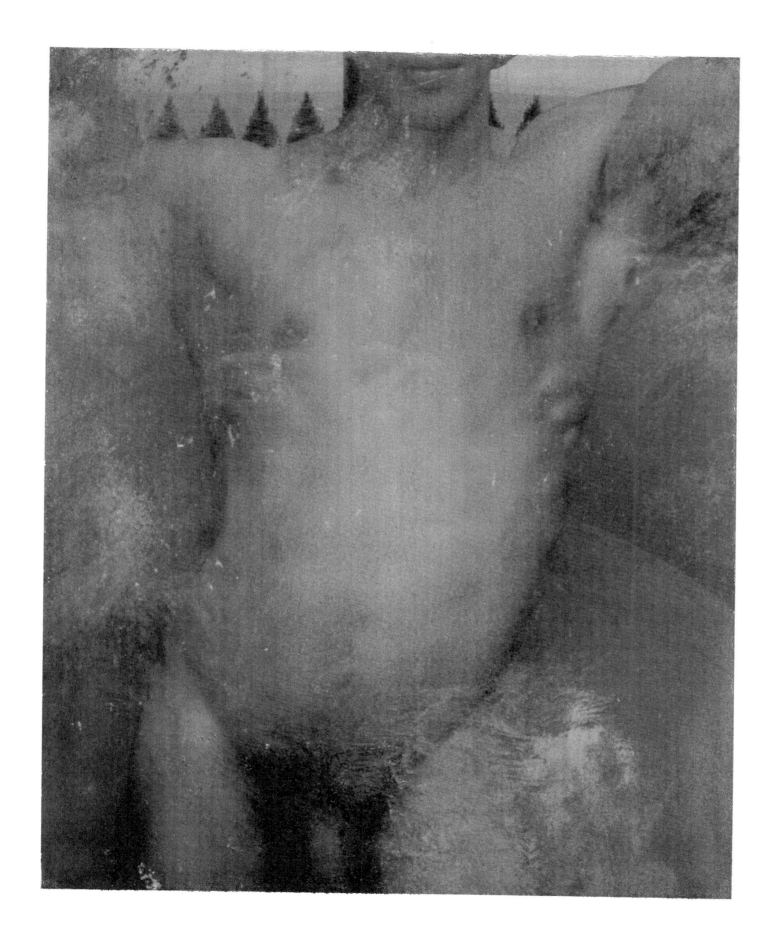

45. Barcelona, España 1994

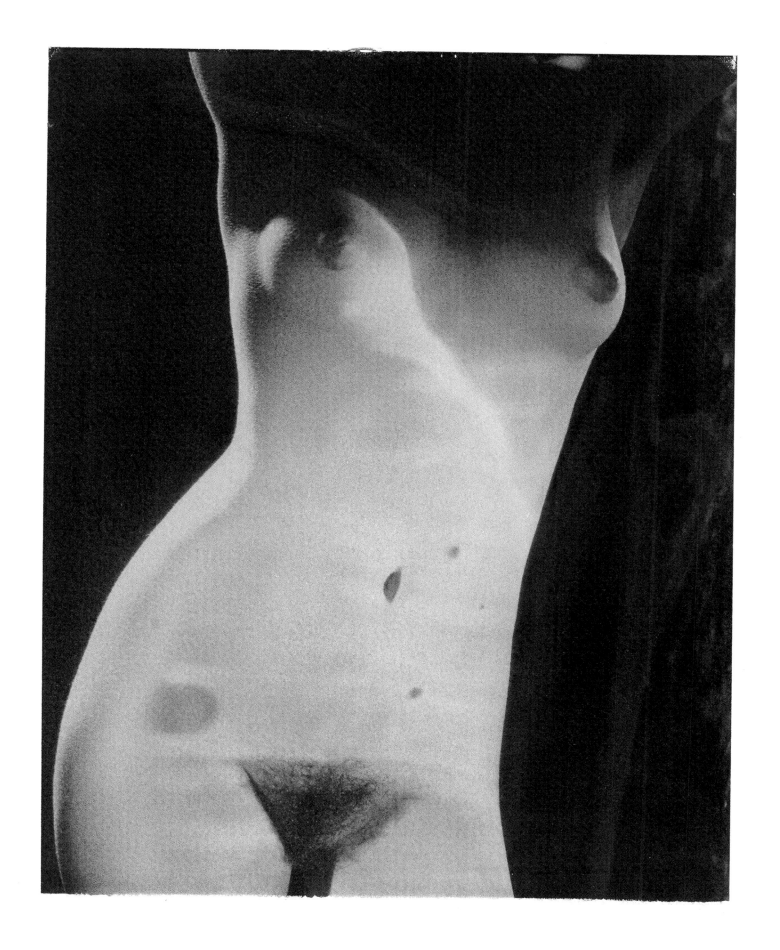

46. Barcelona, España 1994

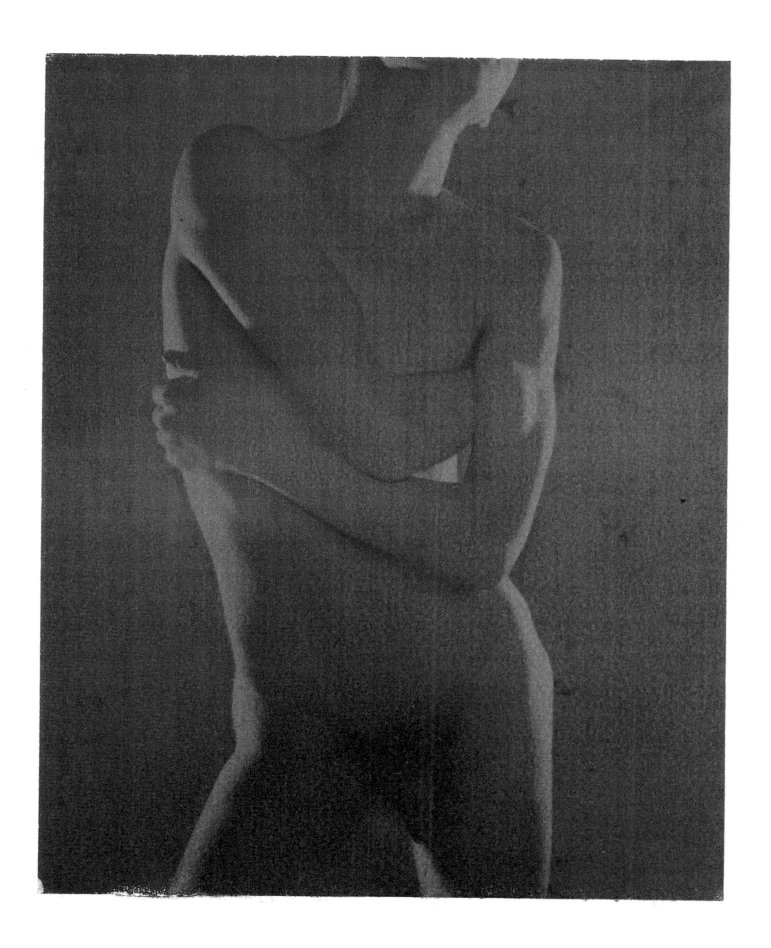

47. *Alexis*. Santiago, Cuba 1997

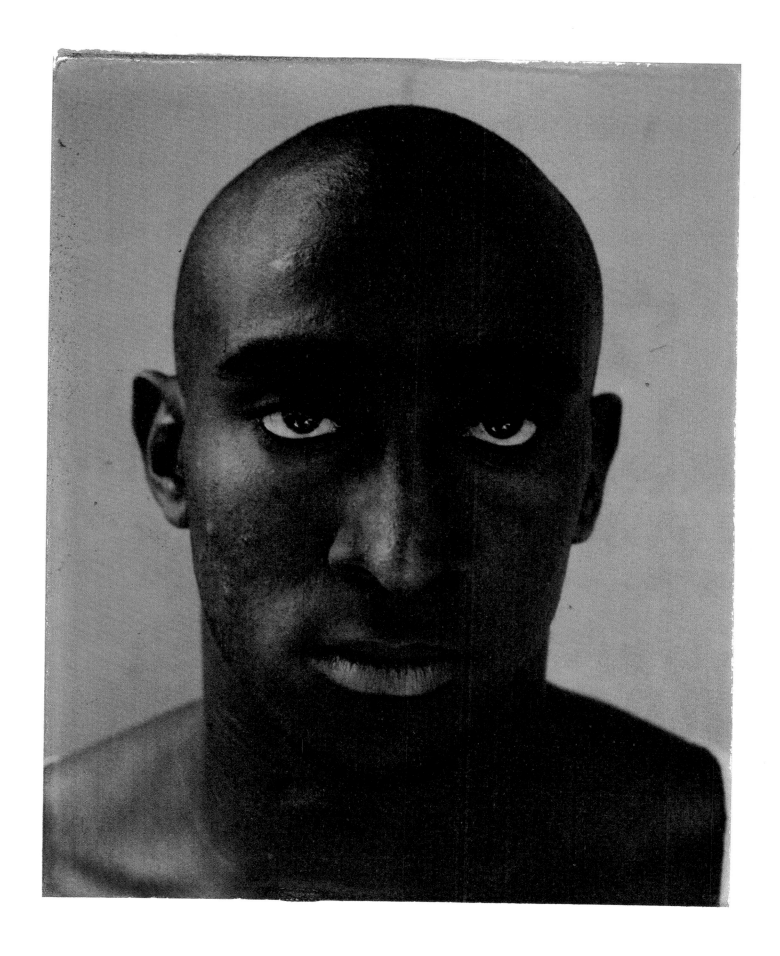

48. *Gala*. Barcelona, España 1994/1997

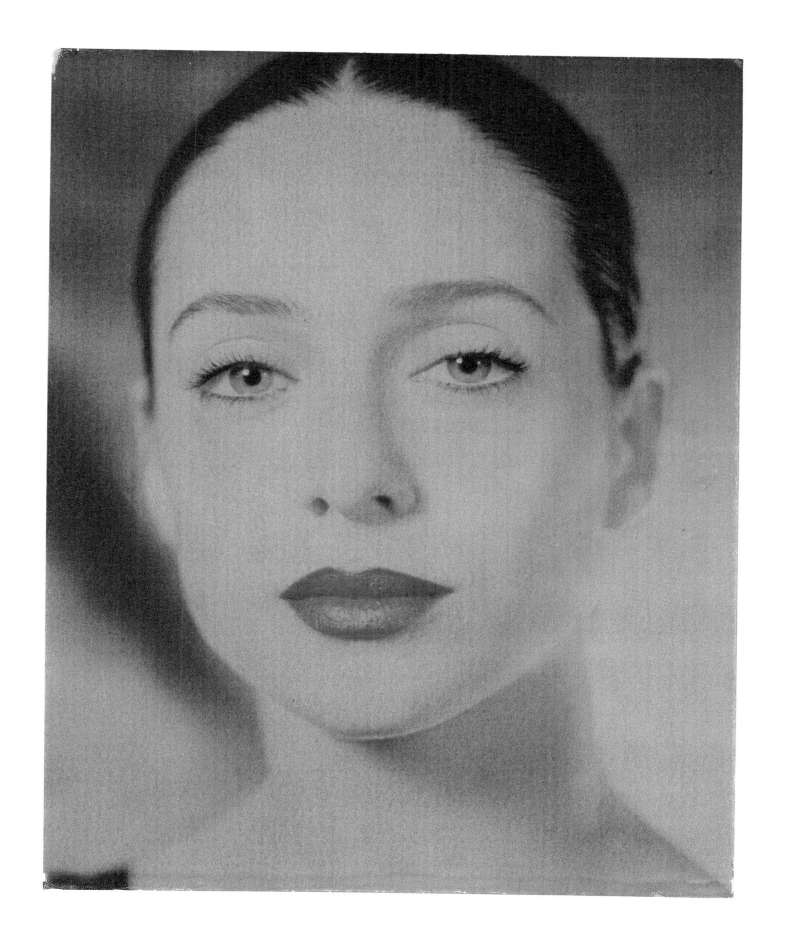

49. Venezuela, 1996

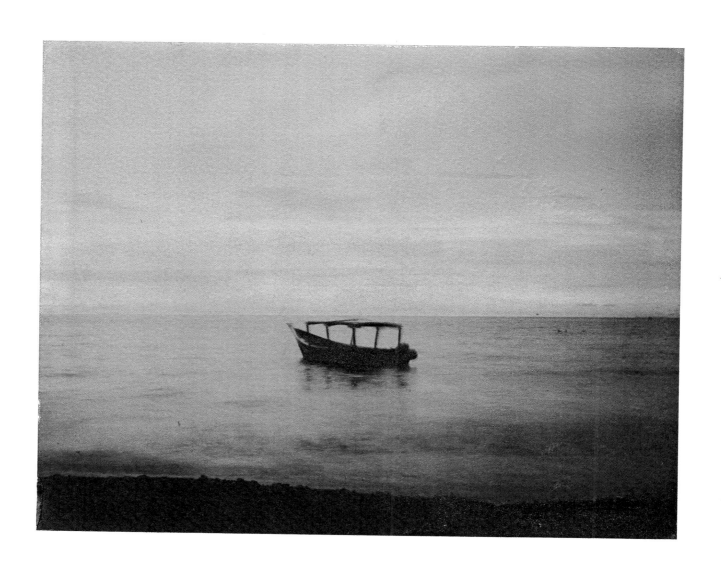

In 1967, after several years of apprenticeship and after buying an old camera, I began a series of photographs using the technique that W. H. Fox Talbot had invented in 1835 — the calotype (negatives on paper printed by contact). I identified with it fully. This series, limited to black and white photographs, included landscapes, still lifes and nudes— subjects that I would later develop separately.

At the same time, and over some ten years, now using more conventional techniques, I devoted myself above all to still lifes, first in black and white and later in colour: *Natures Mortes* (1987).

La meva Mediterrània (1991) is the fruit of my pleasure cruises in the Mediterranean.

Once again inspired by the calotype technique, I devoted four years to the study of the male figure: *Somniar déus* (1993).

On my travels in Libya I tried out Polaroid Polapen film. I liked the results so much that I decided to go back to the Mediterranean: *Obscura memòria* (1994).

And little by little I felt increasingly attracted towards the portrait, in colour. Once again, to obtain the desired results, I changed technique. This time I used Polaroid 609 on watercolour paper or natural silk. This laborious method means that each example can be considered unique. The new result is reminiscent of calotype, but in colour. Besides portraits I photographed still lifes, nudes, landscapes, as in the first series. Like a fish biting its tail.

Perhaps with the photographs in this book, I'm bringing a cycle to a close. Perhaps.

Toni Catany